D0927119

draw your own
CELTIC DESIGNS

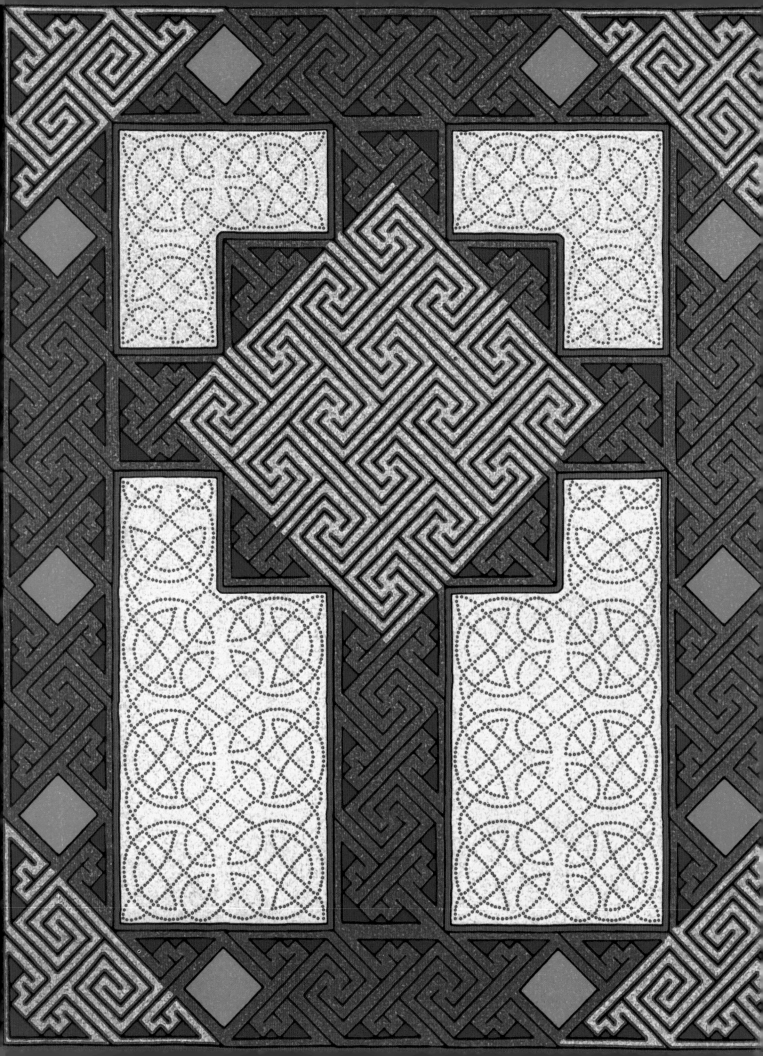

draw your own
CELTIC DESIGNS

David James with Vitor Gonzalez

David & Charles

Dedication

This book is dedicated to the island of Iona in
Scotland's Inner Hebrides. A unique place of
inspiration and beauty.

A DAVID & CHARLES BOOK

First published in the UK in 2003
Reprinted 2006 , 2007
Text copyright © David James 2003
Photographs copyright © Simant Bostock 2003
Artwork copyright © Vitor Gonzalez 2003

Distributed in North America
by F&W Publications, Inc.
4700 East Galbraith Road
Cincinnati, OH 45236
1-800-289-0963

David James has asserted his right to be identified as
author of this work in accordance with the Copyright,
Designs and Patents Act, 1988.

All rights reserved. No part of this publication may be
reproduced, stored in a retrieval system, or transmitted,
in any form or by any means, electronic or mechanical,
by photocopying, recording or otherwise, without prior
permission in writing from the publisher.

A catalogue record for this book is available from
the British Library.

ISBN 0 7153 1525 0 paperback

Printed in China by Dai Nippon
for David & Charles
Brunel House Newton Abbot Devon

Desk Editor Sandra Pruski
Executive Art Editor Alison Myer
Designer Nigel Morgan

Visit our website at www.davidandcharles.co.uk

David & Charles books are available from all good
bookshops; alternatively you can contact our Orderline on
(0)1626 334555 or write to us at FREEPOST EX2110, David
& Charles Direct, Newton Abbot, TQ12 4ZZ (no stamp
required UK mainland).

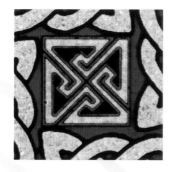

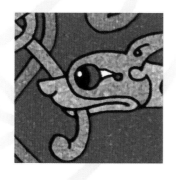

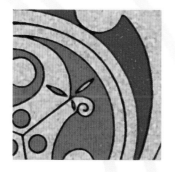

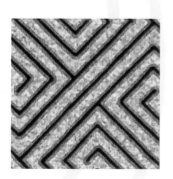

contents

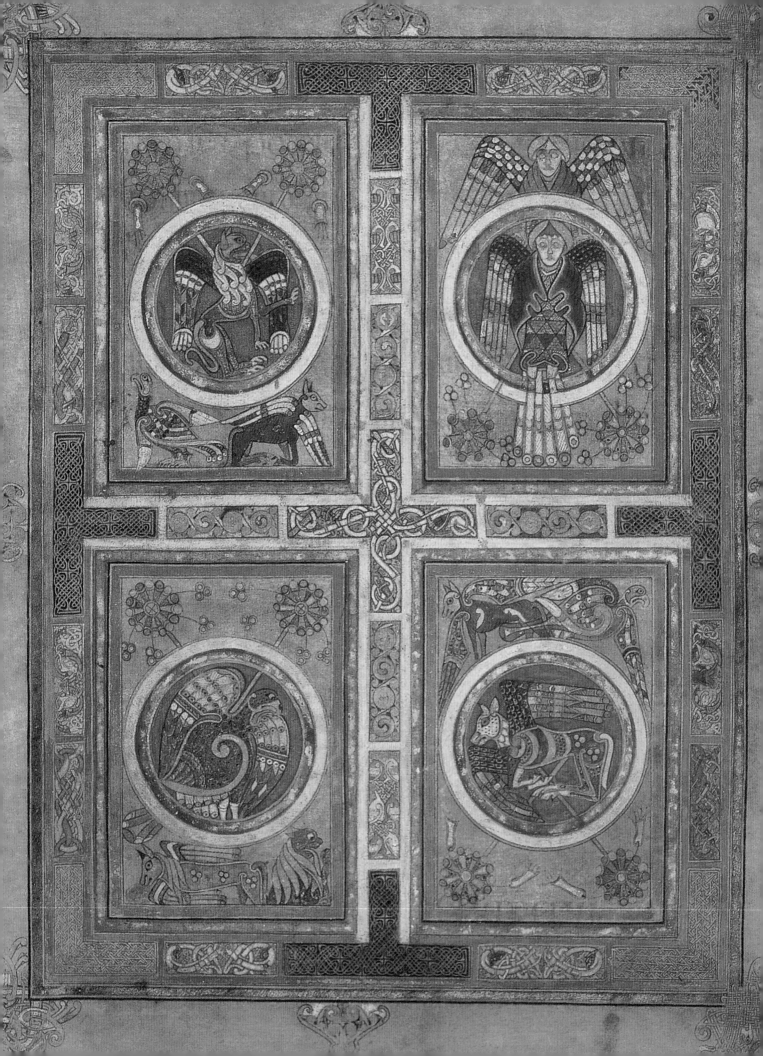

THE ROOTS OF CELTIC DESIGN

The intricate spirals and intertwined knots of Celtic design are still popular today – thousands of years after they were first created. The early Celts were talented craftspeople who adorned metalwork, pottery and jewellery with these now familiar designs. Later, from the 6th century CE, Irish Christian monks took these designs to new levels of intricacy and beauty in their decorated gospel manuscripts. How did this tremendous artistic legacy come about?

WHO WERE THE CELTS?

Most historians place the earliest established origins of the Celts from about 1000-800 BC in eastern Europe. However, recent research and excavations indicate that cultures in Siberia and northern Mongolia dating back as far as the second millennium BC, may be directly linked to the Celts. The prowess of the Celts as expert horsemen who could travel very long distances, give these links further credibility. With their unique expertise in horsemanship the Celts were masters of the chariot – which was an early Celtic invention – and gained a reputation for being formidable opponents in warfare. The name 'Celt' comes from the Greek word *keltoi*, used by classical writers to describe these warrior tribes.

A page showing symbols of the Four Evangelists,
from the 8th century Book of Kells,
one of the wonders of the Celtic art world

THE HALLSTATT PERIOD

One of the main regions of early Celtic occupation was centred around Hallstatt, in modern-day Austria, from about 750-450 BC. Salt was the main commodity used for trading by the Celts during this period and this was a large salt-mining area. Among its various uses salt was vital as a preservative to aid the storage of meat through the bleak winters. It was almost as highly prized as gold. The word 'Hall', often found in present-day Austrian place-names or geographical features, is derived from the ancient word for salt.

Excavations from this region show the use of bronze for weapons as well as for jewellery and functional items. Gold and silver were used to create beautiful pieces of craftwork – although the Celts did not produce or trade with coins during this period. There is also evidence of the beginnings of the production of iron by these peoples, as well as the planting and growing of various types of grains and fruit. The Hallstatt Celts were also adept at making pottery. Excavations have revealed traces of settlements consisting of huts built from wood and evidence to support the existence of a status-conscious society with chiefs and royal families, as shown by the discovery of burials containing gold, imported amber and other precious materials.

A later major Celtic site in this region of Austria, occupied from about 500-300 BC, is at Durrnberg, near Salzburg. As with Hallstatt, the main wealth of the Celts here was based around their production of salt. In 1932 the grave of a Celtic chieftain was discovered in this area which yielded the Durrnberg beaked pitcher. This tall, narrow bronze flagon has

Face motif with spirals from a 4th century BC gold ring found in Sardinia. Facsimile reproduction by Simant Bostock

a handle attachment in the shape of a stylized head and is a masterpiece of Celtic craftsmanship dating from about 400 BC.

THE LA TENE PERIOD

During the 5th century BC in an area of what is now Switzerland, a separate Celtic culture emerged called La Tène, named after an ancient settlement situated beside Lake Neuchâtel. This settlement was discovered in 1858. One main distinguishing feature between the Hallstatt and La Tène cultures was their burial methods. The elite of the Hallstatt period were buried with four-wheeled wooden carts, but burials of the La Tène culture contain the lighter and faster two-wheeled Celtic chariot, which was drawn by two horses yoked to a central pole. (This style of chariot burial continued for several centuries and there are later Celtic examples dating from the 1st century BC in Yorkshire, Britain).

The pottery from the La Tène settlements shows sophistication in both shape and stylized patterns. It was all made by hand, the pottery wheel being unknown to the Celts of this period. The art of the La Tène Celts was an extension of the earlier Hallstatt styles, incorporating bolder and more abstract designs. The gold and silver coins that the Celtic tribes started making and using from the 3rd century BC show strangely disjointed chariots and horses. Each of the many Celtic tribes of the La Tène society eventually produced their own coinage.

The style of the highly skilled metalwork, enamelwork and stone carving from the La Tène period spread and continued to be used throughout Europe until the early 1st century CE. Artefacts such as bronze mirrors with bold swirling spirals and cross-hatching patterns typical of La

Satyr – detail from a La Tène gold torc excavated at Erstfeld, St Gothard, Switzerland. 4th century BC

Tène style decoration have been excavated from several British sites dating from the late Iron Age, and carved stones with this style of swirling decoration are still standing in Ireland.

Though the Celts were adept at living in self-sufficient tribal settlements, rearing their own livestock, and trading with peoples further afield, their constant desire for warfare, conquest, acquisition and wanderlust gave rise to a gradual movement of Celtic tribes throughout Europe, and eventually as far as Britain.

THE WESTWARD MIGRATION OF THE CELTS

By the 4th century BC Celtic tribes had settled in northern Italy, and despite the odds against them carried out a spirited attack on Rome in about 390 BC. Their warfaring exploits led them as far as Greece, where Delphi is recorded as being invaded in 297 BC. Shortly after this a faction of Celtic tribes travelled a further distance to Galatia, now central Turkey, and subsequently settled there.

Late Iron Age engraved stone with La Tène patterns, from Castlestrange, County Roscommon, Ireland

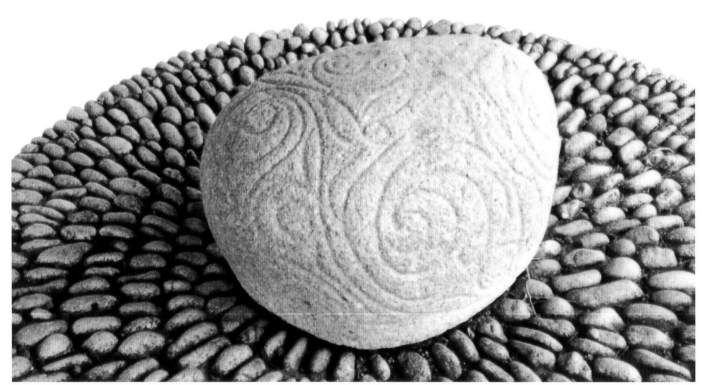

Meanwhile the might of the Roman army had increased vastly during the 2nd century BC. Eventually southern France and subsequently the whole of Gaul was conquered by the Romans. In one of the final battles the Romans defeated the Celtic chief Vercingetorix, immortalized today in the French comic book character Asterix. The Romans forced the Celts north, and it was during this period that many crossed the sea to Britain. From the 2nd century BC they established tribal communities throughout Britain, and over thirty named territories, all fiercely protected by their rulers, are recorded.

THE CELTIC BELIEF SYSTEM

The horse was so central to Celtic culture that it was worshipped as Epona, the horse goddess. Many small effigies of horses in pottery and metal have been found on Celtic sites throughout Europe. The large hillside carvings in chalk soil such as the White Horse of Uffington near Oxford, Britain also testify to this cult. Other animals were also considered sacred to the Celts. The wild boar was a symbol of ferocity both physically and visually, and the Celts believed that its spirit would make their warriors fierce in battle. As well as helmets with boar-effigies on them, several fine freestanding sculptures of the boar have been excavated dating from the 3rd to the 1st centuries BC. The boar is also portrayed on both European and British Celtic coinage from the late Iron Age. The bull, salmon, stag, eagle and raven were also believed by the Celts to have their own attributes and magical powers.

The horned god Cernunnos, sometimes described as Lord of the Animals, was revered by the Celts as the ruler of the natural world. The magnificent Gundestrup Cauldron, a large silver vessel of superb Celtic craftsmanship excavated in Denmark and dating from the 1st century BC, shows among its many decorative images a high-relief depiction of

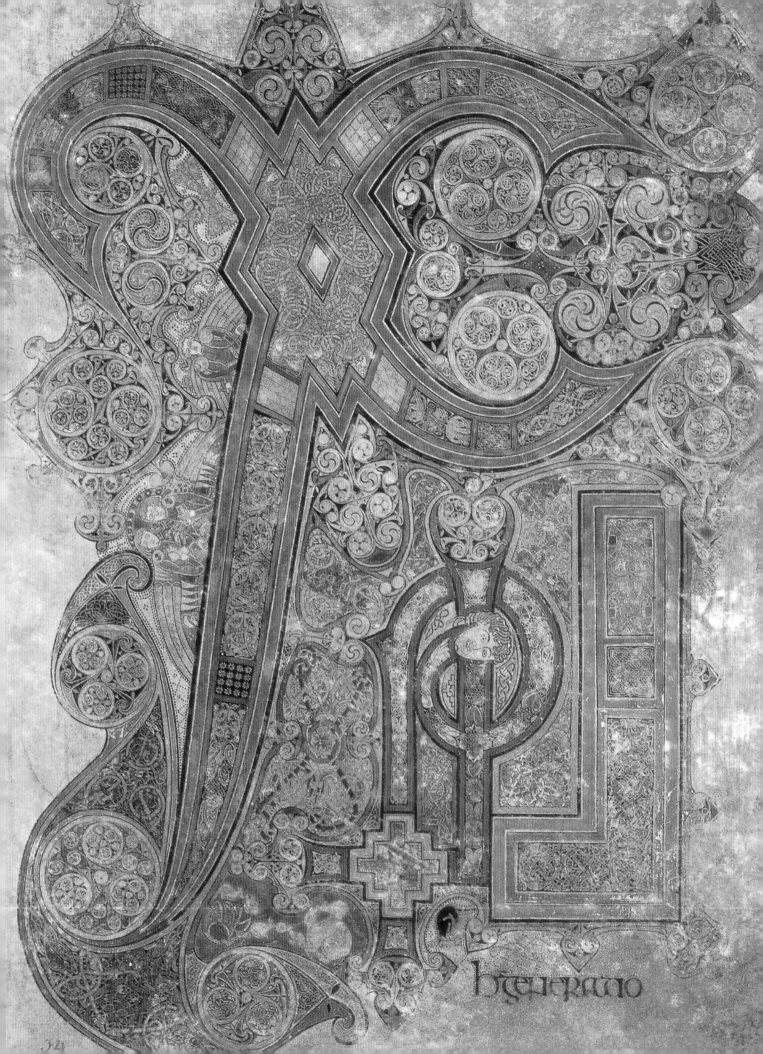

generatio

Cernunnos wearing a head-dress of deer antlers and sitting cross-legged with a torc in his right hand and a snake or serpent in his left. The torc, a twisted band necklace or bracelet, was an item of jewellery beloved by the Celts. Many were elaborately decorated and made of precious metals such as gold. Being circular, the torc was believed to symbolize infinity, or the never-ending cycle of death and rebirth.

THE BOOK OF KELLS AND THE LINDISFARNE GOSPELS

From the 4th century CE the Christian monastic system began to flourish in Ireland. It was from these institutions that the greatest masterpieces of Celtic art were produced – the illuminated gospels.

The magnificent Book of Kells takes its name from the early Irish monastery of this name in County Meath, Ireland. Today, within the ruined monastic site the carved stone Celtic high cross of the monastery is still standing, rather eroded by over one thousand years of exposure to the Irish weather. However some details of the very elaborate knotwork and figures can still be seen on both the cross and its base.

Tradition has it that the Book of Kells was originally created on the tiny sacred island of Iona in Scotland's Inner Hebrides by monks who had travelled there from Ireland. During one of the frequent Viking invasions of the island the book was removed for safekeeping to Ireland and housed at the monastery of Kells in County Meath. The first written reference to the Book is in the *Annals of Ulster*, and dates from 1006. In this book it is documented as having been stolen from the church at Kells and found 'after twenty nights and two months, its gold having been stolen off it, and a sod [placed] over it'.

The Book of Kells is one of the great wonders of the Celtic art world in its beauty and complexity, and dates from the late 8th century. The artists involved in its creation used various brightly coloured natural

Wonderfully ornate Chi-Rho initials from the late 8th century Book of Kells

13

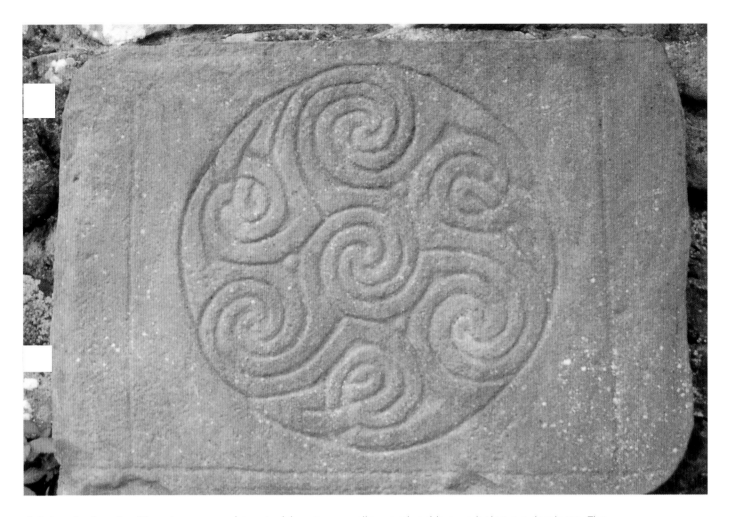

Spiral carving from the 6th century on a stone slab at Carrowtemple, County Sligo, Ireland

pigments; blue, green, yellow and red-brown being predominant. The blue, the most precious and most sparingly-used colour, was made from powdered lapis lazuli certainly obtained from overseas, as this mineral is not found anywhere in Britain or Ireland.

The Lindisfarne Gospels are another wonder of the Celtic art world. The tiny island of Lindisfarne, after which the magnificent gospel manuscript is named, lies off the coast of Northumbria in north-eastern England, separated by a causeway accessible only at low tide. The original Celtic monastic settlement on Lindisfarne was founded by St Aidan in about 635. The Lindisfarne Gospels were written and illuminated on the island over 100 years later.

The Lindisfarne Gospels exhibit the distinctive style of the Irish Celtic artists and is closely related to the Book of Kells. The earliest clue to their origins are contained within the manuscript itself. A priest called Aldred

added an Anglo-Saxon translation of the Latin text in the 10th century, over 200 years after it had originally been created. In addition, on the last page he wrote: 'Eadfrith, Bishop of the Lindisfarne Church originally wrote this book, for God and Saint Cuthbert and, jointly, for all the Saints whose relics are in the island. And Ethelwald, Bishop of the Lindisfarne islanders, impressed it on the outside and covered it, as he well knew how. And Billfrith the anchorite forged the ornaments which are on it on the outside and adorned it with gold and gems and with gilded-over silver, pure metal. And Aldred, unworthy and most miserable priest, glossed it in English between the lines with the help of God and Saint Cuthbert.'

The skills of manuscript illumination were carried to Lindisfarne by the Irish monks of Iona. King Oswald of Northumbria, eager to establish Celtic Christianity in his realm, sent a request to Iona for Irish priests to establish themselves on Lindisfarne. As a result, a group of missionaries led by St Aidan travelled from Iona and founded the monastery on Holy Island, otherwise known as Lindisfarne. St Cuthbert, to whom the Lindisfarne Gospels are dedicated, was St Aidan's successor.

As with many designs in the Book of Kells, the size of the individual panels in the Lindisfarne Gospels is minute, and some form of magnification must have been used to execute them. The main pages are of exquisite complexity, employing highly elaborate spirals, knotwork, key patterning, birds, beasts and illuminated lettering.

THE SPREAD OF ILLUMINATION

The Book of Durrow is the earliest of the surviving Irish illuminated Gospel books and dates from around 675. It takes its name from the monastery of Durrow in County Meath, Ireland, which was founded by St Columba. On the last page of the Book of Durrow there is an inscription added at a much later date testifying that it was present in Durrow monastery

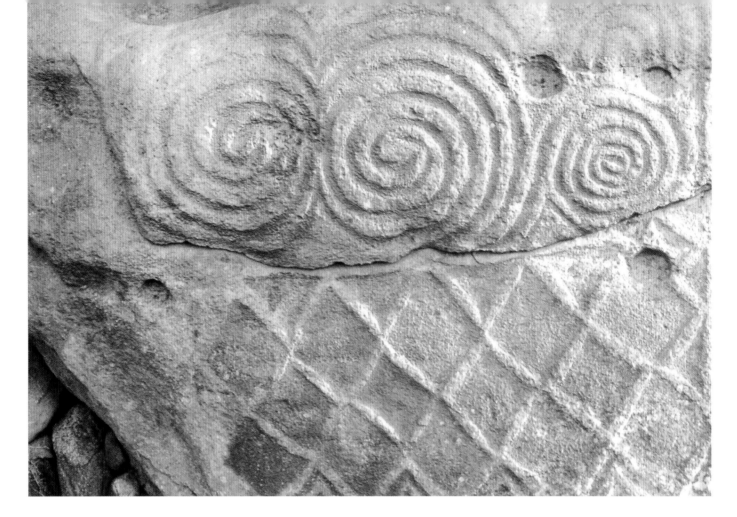

Stones at Newgrange, County Meath, Ireland carved with a basic grid pattern

around the turn of the 12th century, but its actual place of creation is not known. It is now housed in Trinity College Library, Dublin in Ireland.

Several other Celtic illuminated manuscripts, or parts of them, still exist. In Britain, the 8th century Gospels of MacRegol are in the Bodleian Library, Oxford and the 10th century Gospels of MacDurnan are in Lambeth Library, London. In Ireland, the 9th century Book of Armagh is held in the Royal Irish Academy in Dublin.

Around 800 the monastic community at Tours in France, patronized by the emperor Charlemagne, produced several fine, illuminated gospels with strong Northumbrian-Celtic influence. Two of these, The Bible of Charles the Bald, and the St Martin-des-Champs Gospels are in the National Library of Paris, France. Both have striking artistic links with the Book of Kells and Lindisfarne Gospels. Likewise the Gospels of Echternach and Maaseik, and the Trier Gospels of mid 8th century Europe have wonderful illuminated pages of Celtic-influenced artwork.

Other existing examples are the Gospels of Cutbercht, now in Vienna National Library in Austria, and the Barberini Gospels found in the Vatican Library, Rome in Italy. There is also the Montpellier Psalter, now in Montpellier University in France.

These examples of early manuscripts help to give us some idea of the widespread dispersion of Celtic art and design from its roots in the Irish monasteries, western Scotland and Northumbria to various regions of Europe and as far afield as Russia. Celtic art has a truly universal appeal, and is still admired and enjoyed by many today.

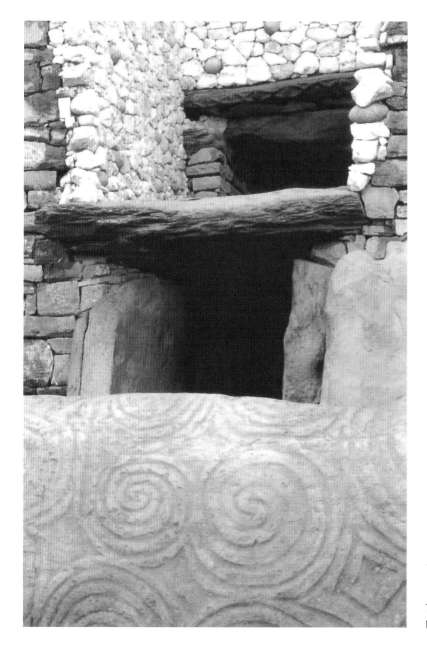

The entrance stone with carved spirals at the Newgrange cairn dates from around 3200 BC

CONTINUING THE ARTISTIC TRADITION

The Celtic artistic tradition is by no means dead. Many contemporary artists and craft workers in many media are using Celtic designs to decorate their creations. Much beautiful modern work in the Celtic style can be found worldwide, and in countries as far away from Celtic roots as Japan the art form has recently become very popular. The best of this work, as with any creative art or craftwork, embodies new and exciting designs. Many Celtic artists use as a foundation the early art forms of both Iron Age Europe and the later Irish monastic styles, sometimes with influences from other early cultures such as Native American or Islamic. By incorporating different styles with the basics of original Celtic design they are able to produce original and beautiful creations that are fresh, vital and alive.

THE MAKING OF ANCIENT MANUSCRIPTS

Sitting in a warm building with pencil and paper readily available for our designs, we should bear in mind the arduous lengths the early Christian monks went to in order to create their wonderful illuminated manuscripts such as the books of Kells, Lindisfarne, Durrow and other lesser-known works.

Their 'paper' was vellum — made from cured calfskin and a very expensive commodity. The vellum was prepared by soaking it in specially prepared liquids and then stretching it over frames and scraping it to make it smooth. In all the major early monasteries there was a room set apart for the preparation and creation of illuminated manuscripts. This room was called the *Scriptorium* and it was in this room that the coloured pigments and inks were kept, as well as the goose or swan-feather quills used for the stylized lettering of the main text of the manuscripts.

The basic materials for the inks and pigments were obtained from

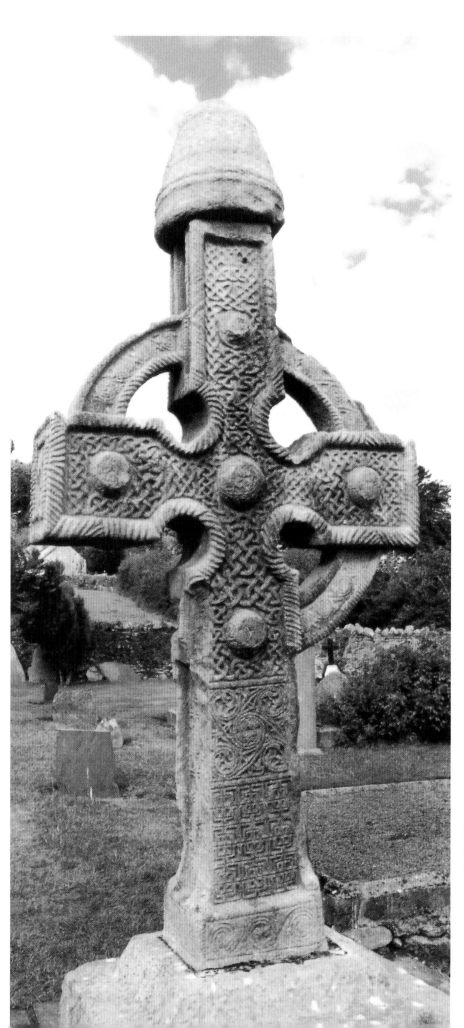

Delicately carved knotwork on the front face of the 8th century Ahenny Cross, in County Tipperary, Ireland

many diverse locations – as far as the foothills of the Himalayas in the case of lapis lazuli, which gave the striking blue pigment found in the Book of Kells and many other manuscripts. Known types of ink used for the main lettering include carbon ink, which was made by mixing soot and gum – brown ink, made from the branches of blackthorn mixed with a small amount of wine – and red ink, made from red lead, which was often used to create a dotted outline for lettering, page borders, and intertwined figures.

Albumen, or egg white, was used as a binding material to hold the coloured pigments together and make them more easily used for painting.

Writing implements varied according to the task in hand. As well as quills of varying sizes cut from goose or swan feathers, a metal stylus was used for scratching characters on to a wax tablet. There was also a metal tool for finely piercing the vellum to make accurate marking-points for the framework of a specific page, and the intricate designs that would eventually be drawn on it. Tiny marking holes can be seen on the reverse of some pages from the Lindisfarne Gospels and other manuscripts as evidence of this. Our knowledge of the precise way in which these early illustrators worked is expanded by their own drawings within medieval manuscripts of monastic scribes at work, showing the tools they used, and how the *Scriptorium* was arranged.

When you take into consideration the specialized processes of producing the inks, pigments and vellum, as well as the time it took to make these materials, and include the estimated figure of one hundred and fifty cattle (worth a seriously large amount of money in those days!) required to produce the vellum for a major manuscript such as the Book of Kells, this gives us a good idea why these wonderful manuscripts were so treasured and valued. Unfortunately this value was seen not just by their owners and creators, but also by plundering raiders such as the

The magnificent gold neck torc, diameter 20cm (8in) from a hoard excavated at Snettisham in Norfolk, England and now in the British Museum. 1st century BC.

Vikings, from whom the manuscripts frequently had to be hidden. Many of the major works were given bindings and protective cases inlaid with gems and precious metals, which added even more to their existing beauty. Both the Book of Kells and the Lindisfarne Gospels are known to have been bound in this fashion.

So when you take up your pencil and start drawing your designs on a fresh sheet of paper, it's worth bearing in mind that the inspired and dedicated originators of the style of art that you are creating were working in cold and often damp conditions, frequently by candle or oil lamp, and with materials that took many hours, if not days, of careful and skilled preparation before they could be used. What's more, because of

the minuteness and intricacy of many of the elaborate Celtic designs, these dedicated scribes frequently suffered blindness or visual impairment at an early age.

Today, when drawing pads and coloured felt pens are readily available from any nearby shop, we should consider ourselves very fortunate that we don't have to skin the nearest calf to produce vellum for drawing and painting our designs on, or arrange for minerals to be imported from the foothills of the Himalayas when our favourite blue felt pen finally dries up!

CREATING YOUR OWN CELTIC DESIGNS

Now it's time to find yourself some paper, some felt-tip pens, paints or crayons, a pencil, a ruler, a pair of compasses and a good-quality soft eraser – which you'll need quite often!

The practical, step-by-step projects in this book show you how to create all the different types of Celtic designs: from swirling spirals to elaborate knotwork and key patterning, stylized birds and beasts to illuminated lettering. Each chapter focuses on a different style and explains the skills and techniques you need to create beautiful Celtic artwork. The simplest projects are found at the beginning of each chapter, then, as you work your way through, the level of complexity and skill needed increases. Likewise, the chapters on Animals and Beasts (page 85) and Celtic Lettering (page 105) come at the end of the book, as both these styles incorporate complex decorative Celtic spirals and knotwork patterns.

The familiar knot, spiral and key patterns are all based on firm geometric principles. These designs are not drawn freehand – their essence is based on geometry: on square grids, circular outlines or triangular guidelines. You will need a ruler and a pair of compasses to make these designs accurately.

If you are a complete novice to this craft, try to work your way through the book methodically. It is not necessary to complete every single design, but make sure you get to grips with the techniques for each different style of design before moving on to the next chapter. Eventually, inspired by the designs shown in this book and armed with the necessary skills, you can go on to create your own unique Celtic designs and apply them to your favourite crafts.

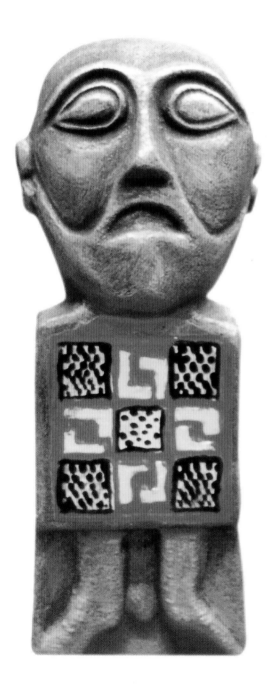

A pair of enamelled figures from a 6th century Irish bronze bowl excavated in Norway

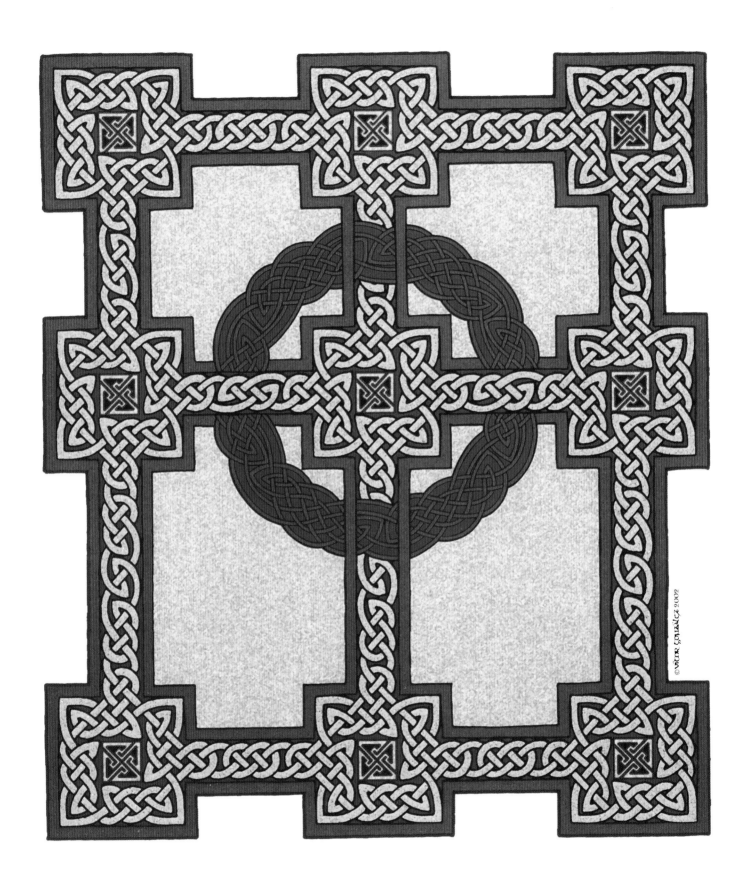

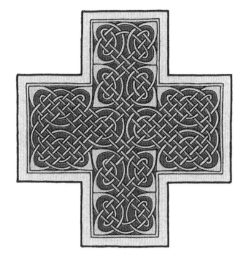

k notwork designs are probably the most well-known of all the Celtic patterns represented in this book. The methods of construction and design-styles of the knotwork patterns in this chapter date back directly to the great illuminated gospels of Kells, Lindisfarne, Durrow and other Christian masterpieces of the 7th and 8th centuries.

The Irish monks developed sophisticated knotwork techniques of extraordinary complexity, but knotwork designs have also been discovered on even older, non-Celtic artefacts. From the tomb of Tutankhamun in Egypt some fine, geometrically constructed patterns have been found dating from about 1350 BC, around 2000 years before the completion of the Book of Kells and the Lindisfarne Gospels. Indeed, examples of simple braiding patterns have been discovered in many earlier cultures worldwide. These very early designs probably derive from basic basket weaving, a craft which was well established in prehistoric times.

However, the variety and complexity of the knotwork patterns created by the Irish early Christian monks have never been superseded. Open any illuminated page of the Book of Kells or the Lindisfarne Gospels and you will encounter a whole host of elaborate and beautiful knotwork patterns.

knots

Design above St John's Cross from the Book of Kells, folio 291V
Design left The Celtic Cross

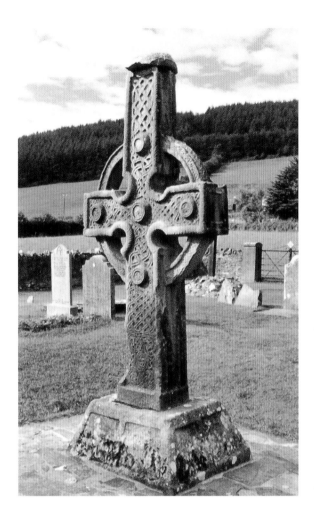

Reverse face of the 8th century Ahenny Cross, County Tipperary, Ireland

Penannular and annular brooches shaped in a complete or almost complete ring are some of the most spectacular jewellery from the early Celtic Christian period. The Irish Tara brooch, dating from the 8th century and originally found at Bettystown, County Meath, Ireland, is probably the finest known example of these wonderful masterpieces. It contains minute and fantastically detailed panels of knotwork, spirals and beasts, and is crafted predominantly from gold with decorated inset silver panels, and set with studs of coloured enamels. Other examples of these types of brooch contain similar insets of amber and coloured glass. The British Museum and the National Museum of Ireland have several fine examples of these wonderful items of high-status Celtic jewellery.

Some of these delicate patterns are so small that their accurate execution has to be marvelled at. Even if some form of magnification was used, to draw designs on this minute scale is an artistic achievement in itself, especially considering the precise geometric basis of their construction. Each design is founded on incredibly accurate and even measurements.

Once the Irish monks of the early Christian era had mastered the principles of knotwork designs, together with spirals and key patterns, they used these decorative devices on stone carving, wood carving, jewellery, metalwork ornamentation and leather embossing. Many of the freestanding, carved stone Celtic high crosses of Ireland, Scotland and Wales contain panels of knotwork. Some of these panels, especially on the Irish crosses, are extremely complex and beautiful, such as the delicate 8th century Irish cross at Ahenny, County Tipperary. A disc-headed cross at Lonan on the Isle of Man, dating from the 10th century,

is unusual in having only knotwork designs all over its face. More basic knotwork designs dating from the 6th century can be found on stone slab carvings at Carrowtemple, County Sligo.

During this period knotwork designs were also used by highly skilled craft workers to embellish metalwork artefacts, creating beautiful religious and secular masterpieces. Examples include the silver chalices of Ardagh and Derrynaflan in Ireland, made in the 8th century and decorated with gold and jewels. There are also some lovely penannular brooches, shaped in the form of an almost complete ring.

This early knotwork patterning was produced using the same principles explained in this chapter. When you have mastered the techniques, you will be able to apply your finished designs to different types of craftwork.

If you have never attempted this type of artwork before, start with some of the simpler designs explained at the beginning of the chapter, then, as your skills and confidence increase, try the more complex panels and borders towards the end of the chapter. The grid is the basis for successful knotwork designs so take special care when drawing it. Another alternative is to trace off the required number of squares from graph paper. By using different sized squares for the grid you can reduce or enlarge the size of the knotwork design. Always remember to draw your curved and angular lines and shapes as carefully as possible in the early stages as this will ensure that your finished design is smooth, flowing and evenly spaced.

Stone slab carving at Carrowtemple, County Sligo, Ireland

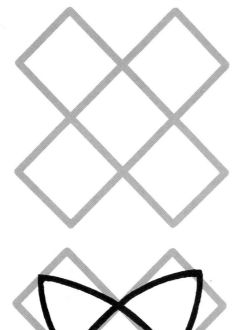

1

knots

STAGE 1 The basis for most knotwork patterns is a carefully constructed grid. Here is a simple grid to start with. Use a soft pencil and either trace the grid from graph paper or use a ruler and draw the grid accurately.

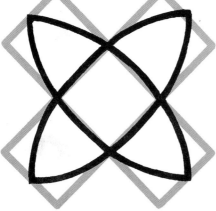

STAGE 2 Using the soft pencil carefully draw a four-pointed outline on to the grid. Work smoothly, allowing the line to flow. Make sure the points accurately touch the edges of the grid as shown.

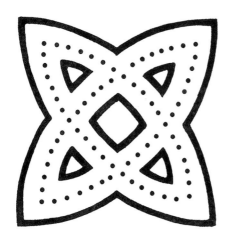

STAGE 3 Trace over the four-pointed shape and transfer to a new sheet of paper, marking the outline as a dotted pencil line. Use the dotted line as a guide and draw around the outside using black felt-tip pen, keeping an equal distance all the way around. Measure the same distance inside the dotted pencil line and draw the window-shapes shown in the diagram. Take care to ensure that the lines are accurately spaced and the curves are smooth and flowing. When you gain experience you won't need to trace off the outline, but can simply rub out the grid and use the solid pencil line from Stage 2 as a guide.

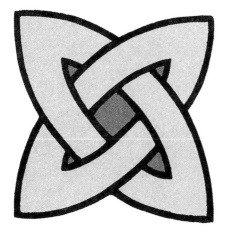

STAGE 4 Join together the black felt-tip pen outlines, making sure that the finished line always goes over and under itself to create the braided band of the Celtic knot. Use the diagram as a guide. Try to keep the band the same width throughout the pattern. Rub out the dotted or solid pencil line and add colour to your knotwork design if wished.

STAGE 1 Use a soft pencil and a ruler and accurately draw the grid as shown in the diagram. Alternatively, trace a grid from graph paper.

STAGE 2 Using the soft pencil carefully draw the knot outline on to the grid. Work smoothly in manageable sections, and allow the lines to flow. Make sure the lines accurately touch the edges of the grid as shown.

STAGE 3 Trace over the knot shape and transfer to a new sheet of paper, marking the outline as a dotted pencil line. Use the dotted line as a guide and draw around the outside using black felt-tip pen, keeping an equal distance all the way around. Measure the same distance inside the dotted pencil line and draw the window-shapes shown in the diagram. Take care to ensure that the lines are accurately spaced and the curves are smooth and flowing. When you gain experience you won't need to trace off the outline, but can simply rub out the grid and use the solid pencil line from Stage 2 as a guide.

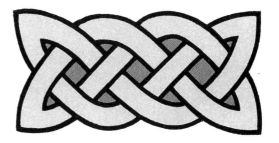

STAGE 4 Join together the black felt-tip pen outlines, making sure that the finished line always goes over and under itself to create the braided band of the Celtic knot. Use the diagram as a guide. Try to keep the band the same width throughout the pattern. Rub out the dotted or solid pencil line and add colour to your knotwork design.

STAGE 1 Use a soft pencil and a ruler and accurately draw the grid as shown in the diagram. Alternatively, trace a grid from graph paper. Draw two short vertical lines through the two squares at each end of the grid as shown in the diagram.

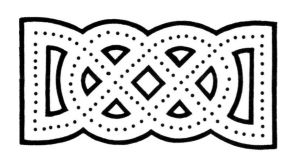

STAGE 2 Using the soft pencil carefully draw the curved lines of the knot on to the grid. Work smoothly in manageable sections, and allow the lines to flow. Make sure the lines accurately touch the edges of the grid. Join the points with two longer vertical lines, to form the flat ends of the finished design.

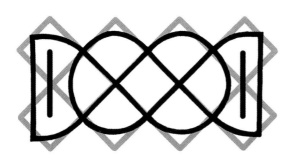

STAGE 3 Trace over the knot shape and transfer to a new sheet of paper, marking the outline as a dotted pencil line. Use the dotted line as a guide and draw around the outside using black felt-tip pen, keeping an equal distance all the way around. Measure the same distance inside the dotted pencil line and draw the window-shapes shown in the diagram. Take care to ensure that the lines are accurately spaced and the curves are smooth and flowing. When you gain experience you won't need to trace off the outline, but can simply rub out the grid and use the solid pencil line as a guide.

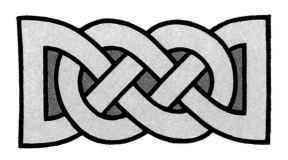

STAGE 4 Join together the black felt-tip pen outlines, making sure that the finished line always goes over and under itself to create the braided band of the Celtic knot. Use the diagram as a guide. Try to keep the band the same width throughout the pattern. Rub out the dotted or solid pencil line and add colour to your knotwork design.

STAGE 1 Use a soft pencil and a ruler and accurately draw the grid as shown in the diagram. Alternatively, trace a grid from graph paper. Draw two short vertical lines through the two squares at each end of the grid, and a third through the top middle of the grid to mark the division of the central knot. Use the diagram as a guide.

STAGE 2 Using the soft pencil carefully draw the curved lines of the knot on to the grid. Work smoothly in manageable sections, and allow the lines to flow. Make sure the lines accurately touch the edges of the grid. Join the points with two longer vertical lines, to form the flat ends of the finished design.

STAGE 3 Trace over the knot shape and transfer to a new sheet of paper, marking the outline as a dotted pencil line. Use the dotted line as a guide and draw around the outside using black felt-tip pen, keeping an equal distance all the way around. Measure the same distance inside the dotted pencil line and draw the window-shapes shown in the diagram. Take care to ensure that the lines are accurately spaced and the curves are smooth and flowing. When you gain experience you won't need to trace off the outline, but can simply rub out the grid and use the solid pencil line from Stage 2 as a guide.

STAGE 4 Join together the black felt-tip pen outlines, making sure that the finished line always goes over and under itself to create the braided band of the Celtic knot. Use the diagram as a guide. Try to keep the band the same width throughout the pattern. Rub out the dotted or solid pencil line and add colour to your knotwork design.

STAGE 1 Use a soft pencil and a ruler and accurately draw the grid as shown in the diagram. Alternatively, trace a grid from graph paper. Draw a short vertical line through the two squares at the right-hand end of the grid, and a vertical and horizontal line at the left-hand end. Use the diagram as a guide.

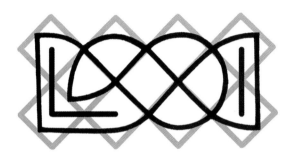

STAGE 2 Using the soft pencil carefully draw the curved lines of the knot on to the grid. Work smoothly in manageable sections, and allow the lines to flow. Make sure the lines accurately touch the edges of the grid. Join the points with two longer vertical lines, to form the flat ends of the finished design.

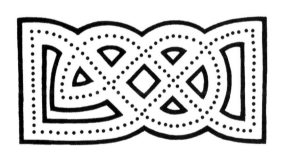

STAGE 3 Trace over the knot shape and transfer to a new sheet of paper, marking the outline as a dotted pencil line. Use the dotted line as a guide and draw around the outside using black felt-tip pen, keeping an equal distance all the way around. Measure the same distance inside the dotted pencil line and draw the window-shapes shown in the diagram. Take care to ensure that the lines are accurately spaced and the curves are smooth and flowing. When you gain experience you won't need to trace off the outline, but can simply rub out the grid and use the solid pencil line as a guide.

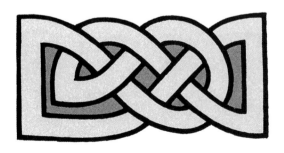

STAGE 4 Join together the black felt-tip pen outlines, making sure that the finished line always goes over and under itself to create the braided band of the Celtic knot. Use the diagram as a guide. Try to keep the band the same width throughout the pattern. Rub out the dotted or solid pencil line and add colour to your knotwork design.

5 knots

STAGE 1 Use a soft pencil and a ruler and accurately draw the grid as shown in the diagram. Alternatively, trace a grid from graph paper. Draw short vertical and horizontal lines to create 'L' brackets at each end of the grid. Use the diagram as a guide.

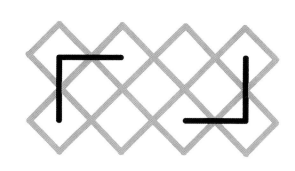

STAGE 2 Using the soft pencil carefully draw the curved lines of the knot on to the grid. Work smoothly in manageable sections, and allow the lines to flow. Make sure the lines accurately touch the edges of the grid. Join the points with two longer vertical lines, to form the flat ends of the finished design.

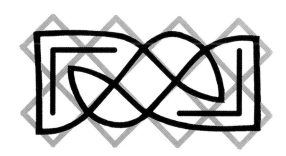

STAGE 3 Trace over the knot shape and transfer to a new sheet of paper, marking the outline as a dotted pencil line. Use the dotted line as a guide and draw around the outside using black felt-tip pen, keeping an equal distance all the way around. Measure the same distance inside the dotted pencil line and draw the window-shapes shown in the diagram. Take care to ensure that the lines are accurately spaced and the curves are smooth and flowing. When you gain experience you won't need to trace off the outline, but can simply rub out the grid and use the solid pencil line from Stage 2 as a guide.

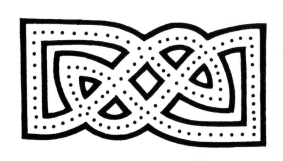

STAGE 4 Join together the black felt-tip pen outlines, making sure that the finished line always goes over and under itself to create the braided band of the Celtic knot. Use the diagram as a guide. Try to keep the band the same width throughout the pattern. Rub out the dotted or solid pencil line and add colour to your knotwork design.

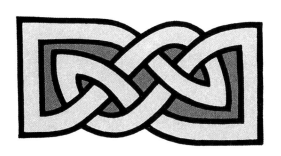

7 knots

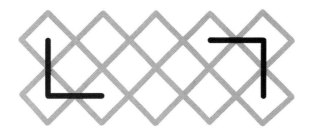

STAGE 1 Use a soft pencil and a ruler and accurately draw the grid as shown in the diagram. Alternatively, trace a grid from graph paper. Draw short vertical and horizontal lines to create 'L' brackets at each end of the grid. Use the diagram as a guide.

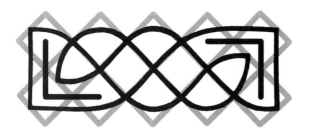

STAGE 2 Using the soft pencil carefully draw the curved lines of the knot on to the grid. Work smoothly in manageable sections, and allow the lines to flow. Make sure the lines accurately touch the edges of the grid. Join the points with two longer vertical lines, to form the flat ends of the finished design.

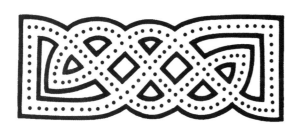

STAGE 3 Trace over the knot shape and transfer to a new sheet of paper, marking the outline as a dotted pencil line. Use the dotted line as a guide and draw around the outside using black felt-tip pen, keeping an equal distance all the way around. Measure the same distance inside the dotted pencil line and draw the window-shapes shown in the diagram. Take care to ensure that the lines are accurately spaced and the curves are smooth and flowing. When you gain experience you won't need to trace off the outline, but can simply rub out the grid and use the solid pencil line from Stage 2 as a guide.

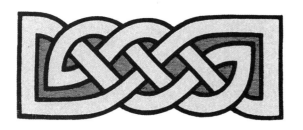

STAGE 4 Join together the black felt-tip pen outlines, making sure that the finished line always goes over and under itself to create the braided band of the Celtic knot. Use the diagram as a guide. Try to keep the band the same width throughout the pattern. Rub out the dotted or solid pencil line and add colour to your knotwork design.

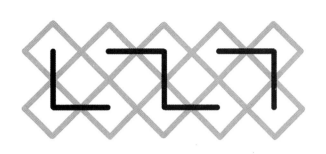

STAGE 1 Use a soft pencil and a ruler and accurately draw the grid as shown in the diagram. Alternatively, trace a grid from graph paper. Draw short vertical and horizontal lines to create 'L' brackets at each end of the grid, and an angular dog-leg in the centre of the grid to mark the central divide of the finished knot. Use the diagram as a guide.

STAGE 2 Using the soft pencil carefully draw the curved lines of the knot on to the grid. Work smoothly in manageable sections, and allow the lines to flow. Make sure the lines accurately touch the edges of the grid. Join the points with two longer vertical lines, to form the flat ends of the finished design.

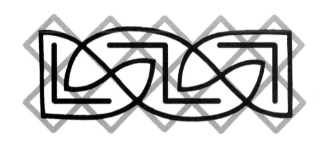

STAGE 3 Trace over the knot shape and transfer to a new sheet of paper, marking the outline as a dotted pencil line. Use the dotted line as a guide and draw around the outside using black felt-tip pen, keeping an equal distance all the way around. Measure the same distance inside the dotted pencil line and draw the window-shapes shown in the diagram. Take care to ensure that the lines are accurately spaced and the curves are smooth and flowing. When you gain experience you won't need to trace off the outline, but can simply rub out the grid and use the solid pencil line from Stage 2 as a guide.

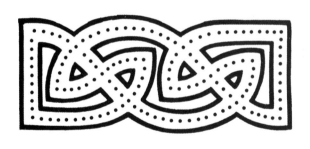

STAGE 4 Join together the black felt-tip pen outlines, making sure that the finished line always goes over and under itself to create the braided band of the Celtic knot. Use the diagram as a guide. Try to keep the band the same width throughout the pattern. Rub out the dotted or solid pencil line and add colour to your knotwork design.

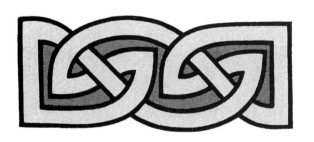

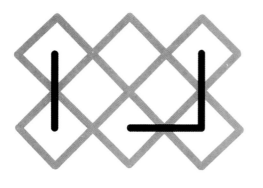

STAGE 1 Use a soft pencil and a ruler and accurately draw the grid as shown in the diagram. Alternatively, trace a grid from graph paper. Draw a short vertical line through the two squares at the left-hand end of the grid, and a vertical and horizontal line to make an 'L' bracket at the right-hand end of the grid. Use the diagram as a guide.

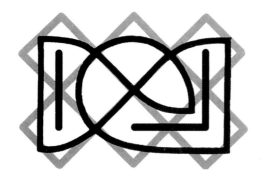

STAGE 2 Using the soft pencil carefully draw the curved lines of the knot on to the grid. Work smoothly in manageable sections, and allow the lines to flow. Make sure the lines accurately touch the edges of the grid. Join the points with two longer vertical lines, to form the flat ends of the finished design.

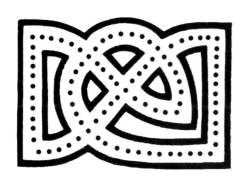

STAGE 3 Trace over the knot shape and transfer to a new sheet of paper, marking the outline as a dotted pencil line. Use the dotted line as a guide and draw around the outside using black felt-tip pen, keeping an equal distance all the way around. Measure the same distance inside the dotted pencil line and draw the window-shapes shown in the diagram. Take care to ensure that the lines are accurately spaced and the curves are smooth and flowing. When you gain experience you won't need to trace off the outline, but can simply rub out the grid and use the solid pencil line from Stage 2 as a guide.

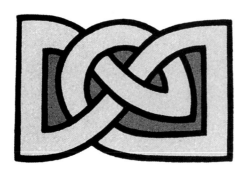

STAGE 4 Join together the black felt-tip pen outlines, making sure that the finished line always goes over and under itself to create the braided band of the Celtic knot. Use the diagram as a guide. Try to keep the band the same width throughout the pattern. Rub out the dotted or solid pencil line and add colour to your knotwork design.

STAGE 1 Draw a circle using a soft pencil and a pair of compasses. Use the compasses to mark the circumference of the circle with six equidistant points. Draw six lines radiating out from the centre of the circle to these points. Draw a large triangle connecting the points of three of these lines. Either freehand or using the compasses, draw a curved line connecting two of the points of the large triangle. Use the diagram as a guide.

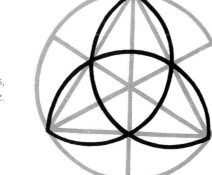

STAGE 2 Either freehand or using the soft pencil and the compasses, add two more curved lines, creating a continuous line.

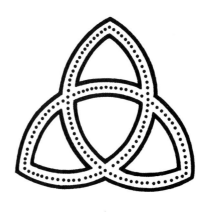

STAGE 3 Trace over the knot shape and transfer to a new sheet of paper, marking the outline as a dotted pencil line. Use the dotted line as a guide and draw around the outside using black felt-tip pen, keeping an equal distance all the way around. Measure the same distance inside the dotted pencil line and draw the window-shapes shown in the diagram. Take care to ensure that the lines are accurately spaced and the curves are smooth and flowing. When you gain experience you won't need to trace off the outline, but can simply rub out the grid and use the solid pencil line from Stage 2 as a guide.

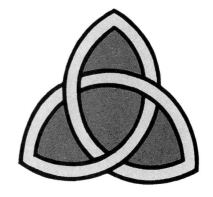

STAGE 4 Join together the black felt-tip pen outlines, making sure that the finished line always goes over and under itself to create the braided band of the Celtic knot. This design is called a triquetra. Use the diagram as a guide. Try to keep the band the same width throughout the pattern. Rub out the dotted or solid pencil line and add colour to your knotwork design.

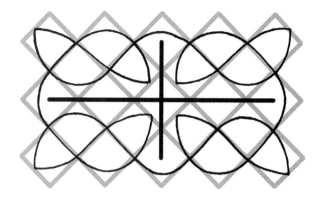

STAGE 1 Use a soft pencil and ruler to draw a five unit by three unit grid or trace a grid from graph paper. Dissect the grid with a vertical and horizontal line as shown in the diagram; this cross will act as a guide for the symmetry of the design. Still using your pencil add the single interweaving line, trying to keep it as smooth and flowing as possible.

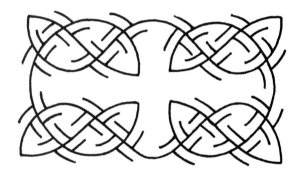

STAGE 2 Using a soft eraser, rub out the background grid, and the central cross that has provided the symmetrical guide or trace over the knot shape and transfer to a clean sheet of paper. Very carefully add the small lines as shown in the diagram. These are the guidelines for two interlacing ribbons.

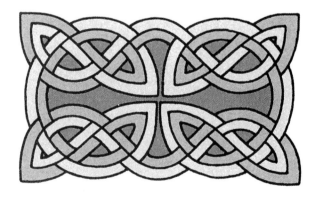

STAGE 3 Join together the small lines using black felt-tip pen to create two continuous ribbons that weave over and under each other. Use the diagram as a guide. Use bright contrasting colours for each side of the double ribbon and a different contrasting colour for the background.

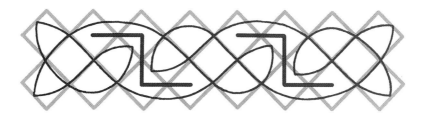

STAGE 1 Use a soft pencil and ruler to draw an eight unit by two unit grid or trace a grid from graph paper. Using vertical and horizontal lines draw two dog-legs that divide the grid into three parts, these lines will be guides for the symmetry of the design. Still using the soft pencil draw the curved lines of the knot, starting first from the top right-hand point and then from the top left-hand point. Keep this line as smooth and flowing as possible.

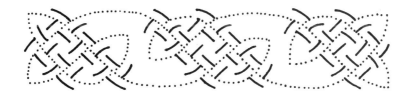

STAGE 2 Using a soft eraser, rub out the background grid, and the angular lines which have provided the symmetrical guide for your knotwork, or trace over the knot and transfer to a clean sheet of paper, marking the outline as a dotted pencil line. Very carefully add the small black lines as shown in the diagram, keeping them equally spaced.

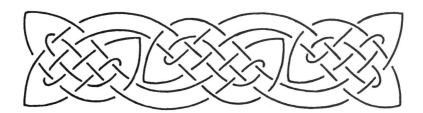

STAGE 3 Using a soft pencil join together the small lines to make an interweaving ribbon.

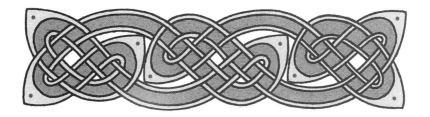

STAGE 4 Using a black felt-tip pen complete the design by making two thin, interweaving ribbons with enlarged corner points. Use bright, contrasting colours for the thin ribbons and the larger space in between them.

13 knots

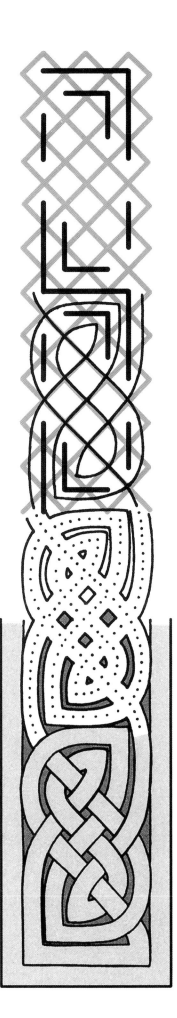

STAGE 1 Use a soft pencil and a ruler and accurately draw a long, narrow grid as shown in the diagram. Alternatively trace a grid from graph paper. Divide the panel into four segments and draw 'L' brackets at opposite corners of each segment and small vertical lines down each side. Use the diagram as a guide.

STAGE 2 Using the soft pencil carefully draw the curved lines of the knot on to the grid, working from top to bottom. Work smoothly in manageable sections, and allow the lines to flow. Make sure the lines accurately touch the edges of the grid.

STAGE 3 Trace over the knot shape and transfer to a new sheet of paper, marking the outline as a dotted pencil line. Use the dotted line as a guide and draw around the outside using black felt-tip pen, keeping an equal distance all the way around. Measure the same distance inside the dotted pencil line and draw the window-shapes shown in the diagram. Take care to ensure that the lines are accurately spaced and the curves are smooth and flowing. When you gain experience you won't need to trace off the outline, but can simply rub out the grid and use the solid pencil line from Stage 2 as a guide.

STAGE 4 Join together the black felt-tip pen outlines, making sure that the finished line always goes over and under itself to create the braided band of the Celtic knot. Use the diagram as a guide. Try to keep the band the same width throughout the pattern. Rub out the dotted or solid pencil line and add colour to your knotwork design.

STAGE 5 Add extra knotwork units until the border is the length required. Using a ruler, draw a band the same width as the knotwork around the design to create a border. Once you feel confident with this process, try extending the grid at right angles to create a complete rectangular border.

STAGE 1 Use a soft pencil and a ruler and accurately draw a long, narrow grid as shown in the diagram. Alternatively trace a grid from graph paper. Divide the panel into four segments and draw four short vertical and three short horizontal lines in each segment, using the diagram as a guide. These will be the guides for each knotwork unit of the border and for joining each unit to the next one.

STAGE 2 Using the soft pencil carefully draw the curved lines of the knot on to the grid, working from top to bottom. Work smoothly in manageable sections, and allow the lines to flow. Make sure the lines accurately touch the edges of the grid.

STAGE 3 Trace over the knot shape and transfer to a new sheet of paper, marking the outline as a dotted pencil line. Use the dotted line as a guide and draw around the outside using black felt-tip pen, keeping an equal distance all the way around. Measure the same distance inside the dotted pencil line and draw the window-shapes shown in the diagram. Take care to ensure that the lines are accurately spaced and the curves are smooth and flowing. When you gain experience you won't need to trace off the outline, but can simply rub out the grid and use the solid pencil line from Stage 2 as a guide.

STAGE 4 Join together the black felt-tip pen outlines, making sure that the finished line always goes over and under itself to create the braided band of the Celtic knot. Use the diagram as a guide. Try to keep the band the same width throughout the pattern. Rub out the dotted or solid pencil line and add colour to your knotwork design.

STAGE 5 Add extra knotwork units until the border is the length required. Using a ruler, draw a band the same width as the knotwork around the design to create a border. Once you feel confident with this process, try extending the grid at right angles to the original design to create a complete rectangular border.

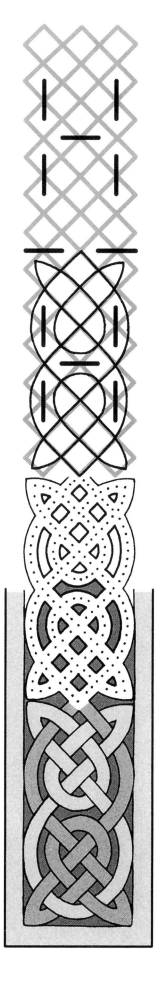

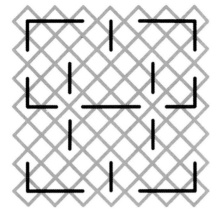

STAGE 1 Use a soft pencil and a ruler and accurately draw a seven by seven unit square grid as shown in the diagram. Alternatively trace a grid from graph paper. Add the vertical and horizontal lines as shown in the diagram as guidelines for the knotwork outline.

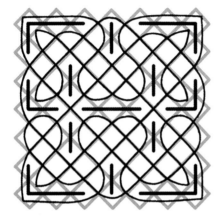

STAGE 2 Using the soft pencil carefully draw the curved lines of the knot on to the grid. Work smoothly in manageable sections, and allow the lines to flow. Make sure the lines accurately touch the edges of the grid.

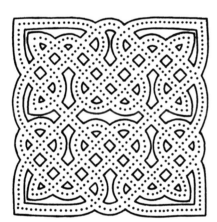

STAGE 3 Trace over the knot shape and transfer to a new sheet of paper, marking the outline as a dotted pencil line. Use the dotted line as a guide and draw around the outside using black felt-tip pen, keeping an equal distance all the way around. Measure the same distance inside the dotted pencil line and draw the window-shapes shown in the diagram. Take care to ensure that the lines are accurately spaced and the curves are smooth and flowing. When you gain experience you won't need to trace off the outline, but can simply rub out the grid and use the solid pencil line from Stage 2 as a guide.

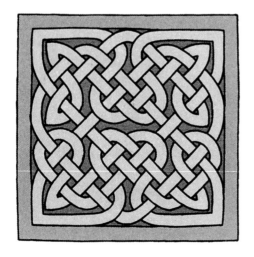

STAGE 4 Join together the black felt-tip pen outlines, making sure that the finished line always goes over and under itself to create the braided band of the Celtic knot. Use the diagram as a guide. Try to keep the band the same width throughout the pattern. Rub out the dotted or solid pencil line and add colour to your knotwork design.

STAGE 5 Using a ruler, draw a band the same width as the knotwork around the design to create an attractive frame for the panel. By experimenting with different sizes of the square grid you can create a larger or smaller panel.

STAGE 1 Use a soft pencil and a ruler and accurately draw a seven by seven unit square grid as shown in the diagram. Alternatively trace a grid from graph paper. Add the vertical and horizontal lines as shown in the diagram as guidelines for the knotwork outline.

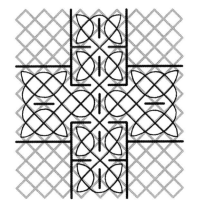

STAGE 2 Using the soft pencil carefully draw the curved lines of the knot on to the grid. Work smoothly in manageable sections, and allow the lines to flow. Make sure the lines accurately touch the edges of the grid.

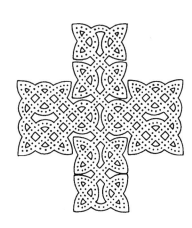

STAGE 3 Trace over the knot shape and transfer to a new sheet of paper, marking the outline as a dotted pencil line. Use the dotted line as a guide and draw around the outside using black felt-tip pen, keeping an equal distance all the way around. Measure the same distance inside the dotted pencil line and draw the window-shapes shown in the diagram. Take care to ensure that the lines are accurately spaced and the curves are smooth and flowing. When you gain experience you won't need to trace off the outline, but can simply rub out the grid and use the solid pencil line as a guide.

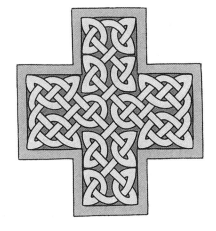

STAGE 4 Join together the black felt-tip pen outlines, making sure that the finished line always goes over and under itself to create the braided band of the Celtic knot. Use the diagram as a guide. Try to keep the band the same width throughout the pattern. Rub out the dotted or solid pencil line and add colour to your knotwork design.

STAGE 5 Using a ruler, draw a band the same width as the knotwork around the design to create an attractive frame for the cross. By experimenting with different sizes of the grid you can create a larger or smaller cross.

43

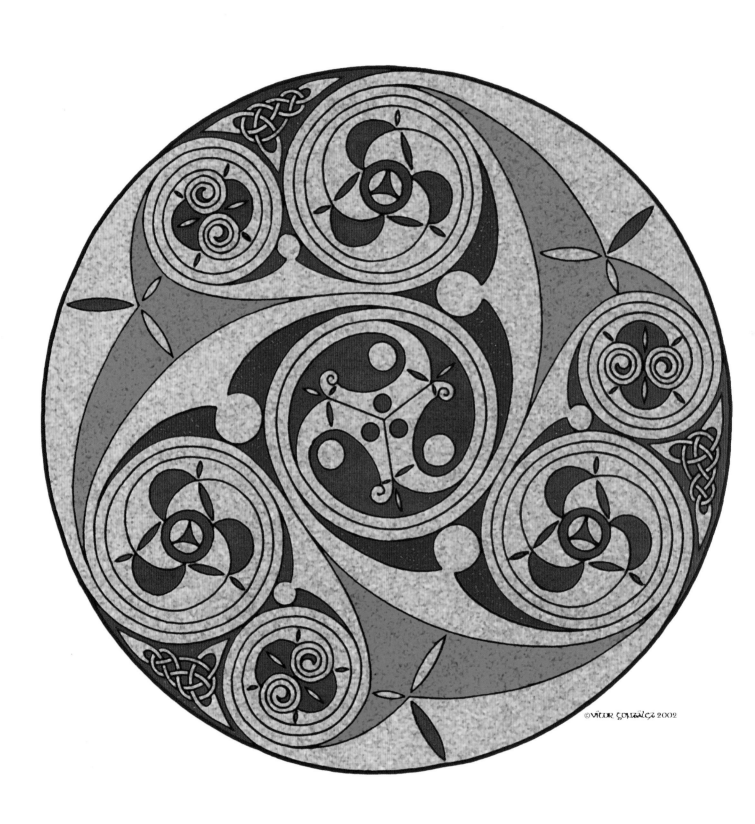

©VICTOR GONZÁLEZ 2002

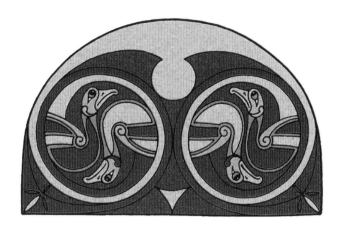

The spiral designs explored in this chapter were perfected by the Irish Christian monks and reached their zenith in the great illuminated gospel manuscripts of the 7th and 8th centuries. By this time a highly sophisticated geometric basis for their construction had evolved: the semicircles used to create these designs were very precisely executed. The Celtic monks used these methods to produce some exquisite artwork. Two well-known examples are the *Chi-Rho* pages found in the Book of Kells (see page 12) and Lindisfarne Gospels. *Chi-Rho* is a combination of two Greek letters used to form the ancient symbol that represented the beginning of the word Christos, or Christ. On these gospel pages elaborate spiral constructions are incorporated into some fine works of Celtic art.

The spiral itself can be found in its basic form as a decorative and symbolic ornament from very early times. A magnificent, simple triple-spiral carving can be found on one of the interior keystones of the well-known chambered cairn at Newgrange in County Meath, Ireland, dating from roughly 3200 BC (see overleaf).

spirals

Design above Peackock's Nest
Design left The Melting Pot

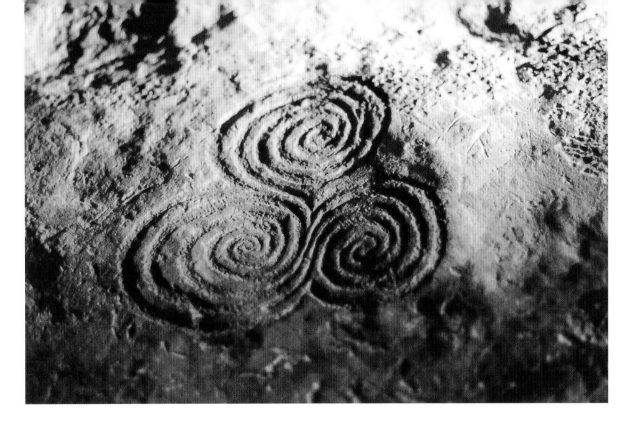

The ancient triple spiral carving at Newgrange, County Meath, Ireland

There are also spiral carvings on the huge entrance stone to the Newgrange cairn. To prehistoric man, the basic spiral would have been a simple and effective decorative device that reflected patterns seen in the natural world, in shells and flowers for example, and also in the movement of flowing streams, rivers and the sea. Ancient spiral carvings almost certainly held symbolic and religious significance, as they are often found at sacred sites and burial chambers.

Throughout the Bronze Age, starting around 3000 BC, and Iron Age, starting around 1000 BC, spirals were use used in a simple but highly effective form to decorate many different types of metalwork, from gold brooches to bronze sword scabbards. During the La Tène period, roughly 400-100 BC, the Celts used elaborately-joined single spirals combined with bold swirling curves to decorate fine metalwork, producing magnificent bronze shields and mirrors, arm and neck torcs (twisted bands), and other items of decorative jewellery often made from gold and silver.

During the early Irish monastic period, from the 4th century CE, elaborate geometric principles were developed and used to construct

the types of spiral artworks shown in this chapter. These spiral designs were also used on early Irish religious stone slab carvings such as those at Carrowtemple, County Sligo which date from the 6th century.

Completed spiral patterns are very beautiful, and are not difficult to draw if you follow each stage carefully. The methods for drawing basic spiral designs are explained at the start of the chapter. It is worth trying some of these simpler designs and getting used to working with compasses and creating very precise shapes, before moving on to some of the more complex patterns shown later in the chapter. Many of the designs incorporate bold freehand curves which need to be drawn very accurately to produce a smooth and flowing finish. The process of creating these beautiful twisting coils may be an exact skill, but you will find the end results richly rewarding.

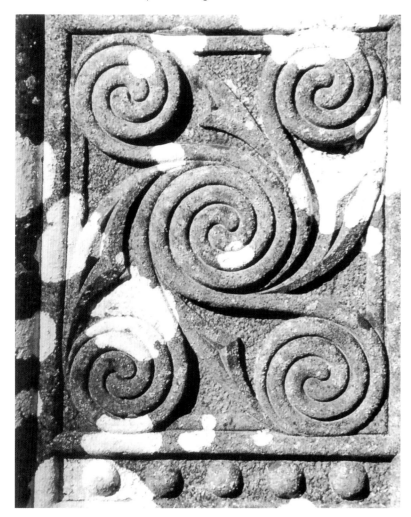

Early 20th century double spiral carvings at Glendalough, County Wicklow, Ireland

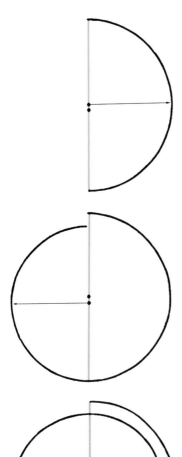

1 spirals

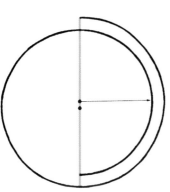

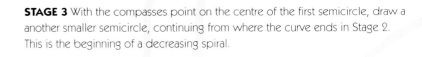

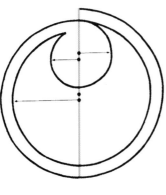

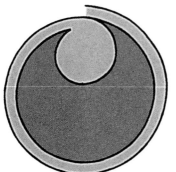

STAGE 1 Using a ruler, a pair of compasses, and a soft pencil, draw a vertical line and a semicircle as shown. Draw the radius of the circle, and mark a small pencil dot just below this radius on the vertical line.

STAGE 2 Using the compasses draw a slightly smaller semicircle, using the dot you have marked in Stage 1 as its centre, and join the two semicircles at the bottom.

STAGE 3 With the compasses point on the centre of the first semicircle, draw a another smaller semicircle, continuing from where the curve ends in Stage 2. This is the beginning of a decreasing spiral.

STAGE 4 Using the centre point of the semicircle from Stage 2, continue the inward-progressing curve as shown, stopping short of the vertical line. Now draw a much smaller semicircle, which meets the inward-progressing curve. Draw in its small radius, and mark a point just above it. Using this point, continue the small curve so that it joins up to the small semicircle below and the larger semicircle above, as shown.

STAGE 5 Using a black felt-tip pen go over the pencil lines to complete the single spiral design. When the ink is dry, rub out any remaining pencil lines with a soft eraser. Add colour using bright, contrasting coloured paints or felt-tip pens. Be adventurous – by experimenting with different colour schemes you can create very beautiful effects.

STAGE 1 Using a ruler, a pair of compasses, and a soft pencil draw a vertical line and a semicircle on the left. Use the method explained in Spirals 1 (page 48), alternating between two fixed compass points, to create an inward-progressing spiral. Add the radius lines that will be a guideline for symmetry in the next stages.

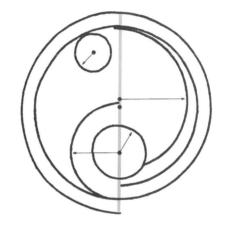

STAGE 2 Using the compasses or working freehand, add the two small circles as shown in the diagram. Place the compasses point at the centre of the small bottom circle and draw a semicircle on the left then, using the dot from Stage 1, draw a shortened semicircle on the right.

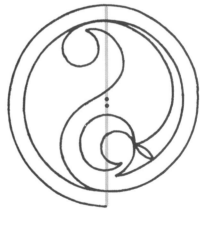

STAGE 3 Using a soft pencil draw freehand curves using the two small circles as guides. Add the small single 'leaf' decoration at the bottom of the design.

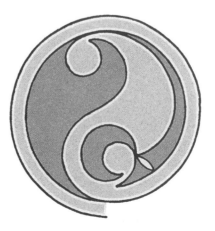

STAGE 4 Go over the outline of your main design in black felt-tip pen. When this is completely dry, use a soft eraser to rub out the pencil guidelines. Using coloured felt-tip pens or paints, add different colours to the main spiral pattern and the background of the design. Bright contrasting colours can be very effective. Be bold and adventurous with your colours, and experiment with different colour combinations.

2 spirals

3 spirals

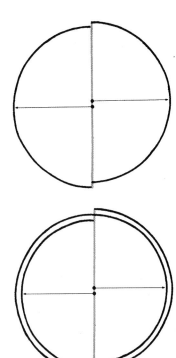

STAGE 1 Using a soft pencil draw a vertical line, and mark two dots close together as shown. Using a pair of compasses, draw two semicircles of the same size, one from each of the dots. Draw in the radii that will serve as guidelines for the next stages.

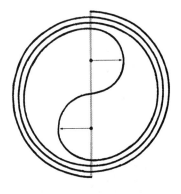

STAGE 2 Place the compasses on the top dot and adjust them so that the next semicircle starts from the top end of the semicircle on the left. Then place the compasses on the lower dot and adjust them so that the next semicircle starts from the bottom end of the semicircle on the right. This creates two inward-progressing spiral lines.

STAGE 3 Add two more semicircles to create three lines on either side of the design, as shown in the diagram.

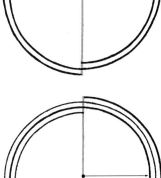

STAGE 4 Using the compasses draw two small semicircles so that they meet the ends of the inward-progressing spirals, and link up to form a reversed 'S' shape.

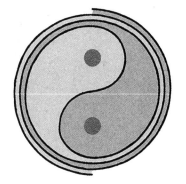

STAGE 5 Using black felt-tip pen, go over the main lines of the spiral that forms a 'yin-yang' design with added coils. Add the dots to the design and when the ink is dry, rub out any pencil lines with a soft eraser. Use coloured felt-tip pens or paints to add contrasting colours to the different elements of the design.

STAGE 1 Follow Stages 1-3 of Spirals 3 (page 50) to create the inward progressing spiral shown in the diagram.

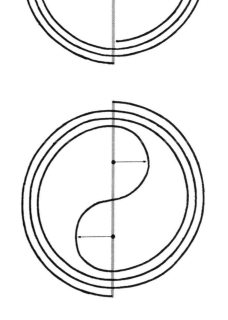

STAGE 2 Using the compasses draw two small semicircles so that they meet the ends of the inward-progressing spirals, and link up to form a reversed 'S' shape as shown.

STAGE 3 Using a soft pencil draw in the diagonal zigzag line that passes through the centre of the spiral design.

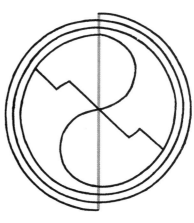

STAGE 4 Using black felt-tip pen carefully go over the outline of the design, and when the ink is dry rub out any remaining pencil guidelines. For a subtle effect leave a very thin white border as shown between the black outline and the background colour you choose.

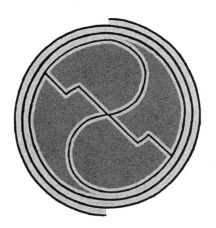

5 spirals

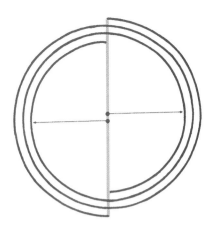

STAGE 1 Follow Stages 1-3 of Spirals 3 (page 50) to create the inward-progressing spiral shown in the diagram.

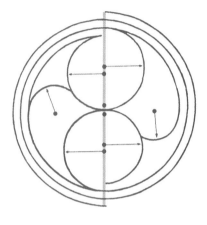

STAGE 2 Draw four small semicircles, two on each side of the central vertical line and slightly offset. Make sure the ends of these semicircles meet up with the inward-progressing spirals. Draw two curved lines, one on the left and one on the right of your design, progressing from the inner spiral lines. Rub out the inner spiral line on the bottom left and top right quarter of the design.

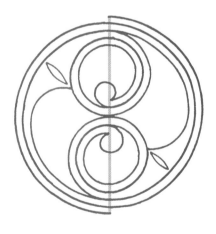

STAGE 3 Using the same technique explained in Stage 1 create two inward-progressing spirals within the small offset semicircles and add rounded ends. Add the two small 'leaves' that touch the inner edge of the larger spiral.

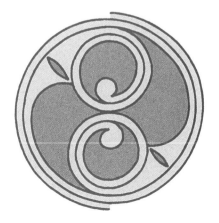

STAGE 4 Using a black felt-tip pen go over the main lines of your two-coil spiral. Once the ink is fully dry, rub out any pencil guidelines remaining with a soft eraser. Using coloured felt-tip pens or paints, add different colours to the main spiral pattern and the design background.

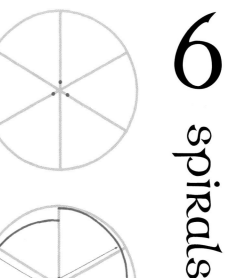

STAGE 1 Begin by drawing a single circle. Using your compasses, carefully mark the circumference of this circle with six equidistant points and using a ruler, carefully draw three lines through the centre of the circle joining these points. Add three dots on these lines as shown. Remember that with any Celtic design the accuracy of the first stage determines the accuracy of the finished design.

STAGE 2 Using a soft pencil and working freehand, start from one of the six points marked on the circumference of the circle and draw a line that curves inwards. Draw another two curves as shown. Makes sure each line is clean and flowing, and most importantly that each inward curve touches its corresponding radial line at the same distance from the centre of the circle.

STAGE 3 Continue with the inward progression of each of these three curved lines, taking care that the spacing between them is as equal as possible. Stop each line exactly on the radius lines of the segmented circle.

STAGE 4 Mark three points on the radial lines as shown, making sure that these are equidistant from the centre of the circle and the ends of the curves you have drawn in Stage 3. Draw three semicircles, progressing from the spiral lines in Stage 3 and ending in the centre of the circle, as shown.

STAGE 5 Using a black felt-tip pen carefully go over the outline of the completed three-coil spiral. When the ink is completely dry, remove any remaining pencil lines using a soft eraser. Add the dots to the design as shown and colour-in the spiral with contrasting colours.

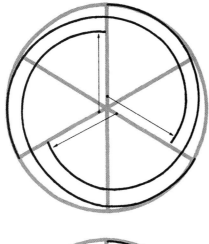

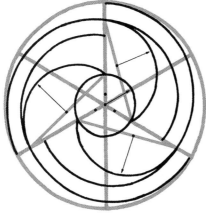

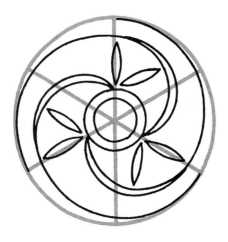

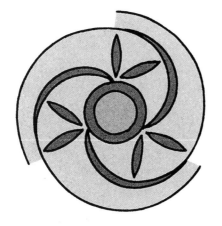

7 spirals

STAGE 1 Follow Stages 1-3 of Spirals 6 (page 53) to create the two-coil, inward-progressing spiral shown in this diagram.

STAGE 2 Add the triangular guidelines as shown in the diagram and then, using compasses, draw in a small central circle touching the corners of the triangles as shown. Add three curved lines that meet this circle, making sure to keep the curves as accurate as possible, as these are the basis for the finished design.

STAGE 3 Add the smallest inner circle, the three pairs of 'leaves', and the three secondary curves drawn just outside the curved lines drawn in Stage 2. Draw these secondary curves very accurately. Some spiral lines can now be erased as they were only needed as guidelines.

STAGE 4 Go over the main spiral lines with black felt-tip pen to create the outline of your finished design. Once this has dried, rub out any pencil lines from previous stages. Adding colour to the completed spiral design can be most effective. Experiment with bright contrasting colours for each separate spiral, the sets of 'leaves', the centre circle, and the background.

STAGE 1 Follow Stages 1-3 of Spirals 6 (page 53) to create the inward-progressing spiral shown in this diagram.

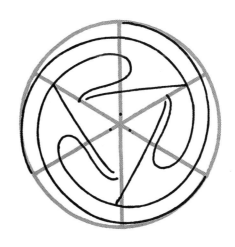

STAGE 2 From the ends of the three spiral lines add the curved lines shown which form the basis for the heads and beaks of the birds.

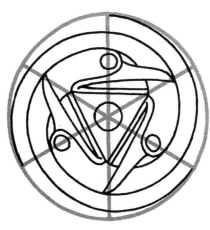

STAGE 3 Using the diagram as a guide join up the lines to create the birds' beaks and add the eyes and the central triangle with its small circle. It is important to create a symmetrical design surrounding the small central circle.

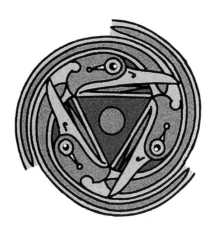

STAGE 4 Using black felt-tip pen, carefully go over the inward-spiralling pencil lines, and the outlines of the heads, beaks and eyes of the three birds. When the ink is completely dry, remove any pencil guidelines using a soft eraser. Colour in the design using felt-tip pens or paints. Use different colours for the beaks, eyes, the spirals and the centre triangular section. The finished design can also look very effective in black and white, using different shades of grey to emphasise each of the sections.

9 spirals

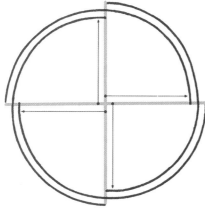

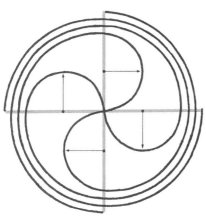

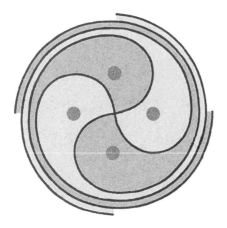

STAGE 1 Using a soft pencil and a ruler draw a cross, making sure it is absolutely symmetrical. Use the compasses as a guide if necessary. Mark four equidistant points close to the centre of the cross, as shown. Using each of these as the centre for the compasses point, draw in four quadrant curves.

STAGE 2 Using the compasses make four more quadrant curves, working inwards.

STAGE 3 Draw four more quadrant curves, continuing to work inwards. Draw four semicircles from the quadrant curves to the centre of the circle. Keep these as accurate as possible as they form the basis for the finished four-coil spiral design.

STAGE 4 Using a black felt-tip pen go over the outline of the completed four-coil spiral. When the ink is completely dry, remove any remaining pencil lines from the previous stages using a soft eraser. Add the four small circles to the design as shown and add bright contrasting colours for each pair of coils.

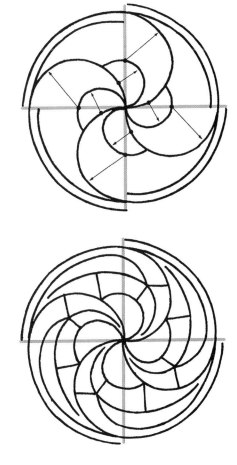

STAGE 1 Follow Stages 1-2 of Spirals 9 (page 56) to create the spiral shown here.

STAGE 2 Using the compasses draw four semicircles from the quadrant curves to the centre of the circle and four smaller semicircles as shown in the diagram. The thin lines with arrows indicate the radii of each of these semicircles. Note where the larger semicircles join the four main spiral lines, and be sure to keep the joins as smooth and accurate as possible.

STAGE 3 The design is becoming more elaborate so work slowly and carefully, remembering that the symmetry of the lines and curves in each quadrant is very important. Using the soft pencil add the additional curves and guidelines shown in this stage.

STAGE 4 Using a black felt-tip pen go over the outline of the completed four-coil spiral, adding all the curved sections, the small leaves', and small decorative triangles. When the ink is completely dry, remove any remaining pencil lines from the previous stages using a soft eraser. Adding colour to this finished four-coil spiral design can be most effective. Experiment with bright contrasting colours for the darker, lighter and white parts of the design as shown in the diagram.

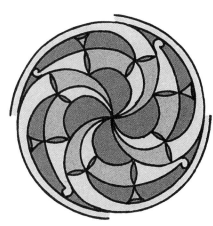

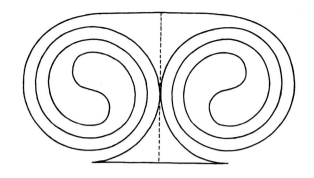

11 spirals

STAGE 1 Follow Stages 1-4 of Spirals 3 (page 50) to create two inward-progressing spirals next to each other. Ensure that the circles are horizontally in line, and draw them so that their circumferences touch each other. Note that the rotation of the left-hand spiral is reversed. Add the vertical dotted line between the two circles as a guideline for symmetry. The outer ends of each spiral join over the top and form a triangle below.

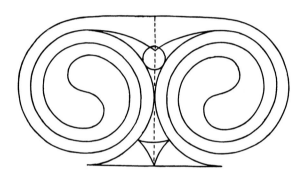

STAGE 2 Using the dotted line as a guide, pencil in the small triangle at the bottom of the design and the small circle at the top, with the two curved lines that meet inside it.

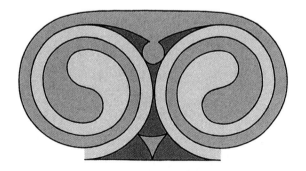

STAGE 3 Using a black felt-tip pen go over the outline of the two spirals design. When the ink is completely dry, rub out any pencil lines using a soft eraser. Colour-in using bright, contrasting colours.

STAGE 4 The completed design is one unit of a two-coil spiral border. By adding additional units on either side and by carefully joining them, you can extend the border to the length you require. Make sure you keep all the units in a straight line.

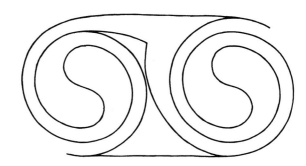

STAGE 1 Follow Stages 1-4 of Spirals 3 (page 50) to create two inward-progressing spirals next to each other. Note that the rotation of both spirals is reversed. Ensure that the circles are horizontally in line, and draw them so that there is a space between them. Add the line that joins the spirals at the top and the angular line, as shown, between the spirals, and the triangular unit at the bottom of the design.

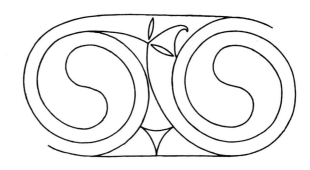

STAGE 2 Add the small 'wave' between the spirals, the decorative 'leaves', and the small inner triangle at the bottom of the design. Add these carefully as they form part of the basis of the finished border.

STAGE 3 Using a black felt-tip pen go over the outline of the spirals design, adding the extra tiny decorative 'leaf'. When the ink is completely dry, rub out any remaining pencil guidelines using a soft eraser. Add colour if wished.

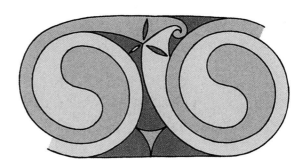

STAGE 4 The completed design is one unit of a two-coil spiral border. By adding additional units on either side of the single unit and by carefully joining them, you can extend the border to the length you require. Make sure you keep all the units in a straight line.

13 spirals

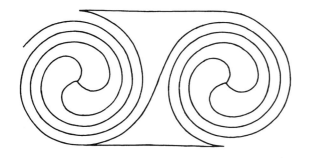

STAGE 1 Follow Stages 1-4 of Spirals 6 (page 53) to create two, three-coil spirals. Make sure they are horizontally in line, leaving a gap between them. Connect the two spirals with a curved line as shown in the diagram. Using a ruler draw the top and bottom horizontal lines and join these to the ends of the spirals. Make sure that you connect the correct ends to these horizontal lines.

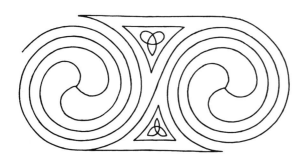

STAGE 2 Within the two triangular sections of the spirals unit, draw two smaller triangles as shown. Add the interweaving lines as guides for the two triquetra (triple knots) in the next stage.

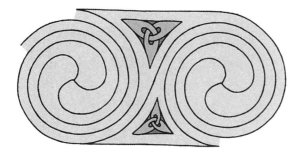

STAGE 3 Use the single line as a guide and draw around the outside and inside to create the interweaving triple knot (see page 37). Using a black felt-tip pen go over the spiral and knotwork design. When the ink is dry, use a soft eraser to remove any pencil marks. Add colour if wished.

STAGE 4 To make a border, add additional units of three-coil spirals either side of this single unit, making sure you keep all the units in a straight line. By carefully joining them, you can extend the border to the length you require.

STAGE 1 Follow Stages 1-4 of Spirals 6 (page 53) to create two, three-coil spirals. Note that the spirals are reversed in this design. Make sure the two circles with their guidelines and guide points are horizontally in line, and leave a substantial gap between them. Using a ruler draw the top and bottom horizontal lines, and add the two curved and angled lines that join the two, three-coil spirals together in the middle.

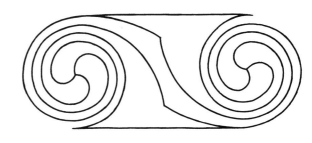

STAGE 2 From the angular point on each of the two centre lines which join the spirals, draw in the small curves at the top and bottom of the design with your pencil. Draw these accurately as the small curves become the basis for two small, simple spirals.

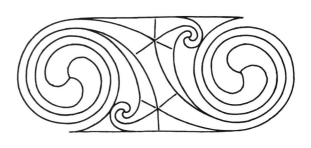

STAGE 3 Carefully follow the diagram and add the curved lines that complete the two small spirals at the top and bottom of the design. These should be symmetrically spaced, so that you can then add the short guidelines for the small 'leaves' as shown. These short guidelines should all be the same length. If necessary, use a soft eraser and adjust the curved lines to create an accurate design.

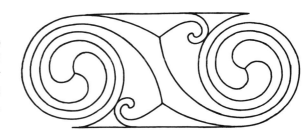

STAGE 4 Using a black felt-tip pen go over the outline of the spirals unit, and add the six small 'leaves' and four small triangles as shown. When the ink is dry, use a soft eraser to rub out any pencil guidelines from the previous stages. Add colour if wished.

STAGE 5 This is a single unit of two, three-coil spirals and you can add additional units on either side and join them carefully to create a border. Make sure you keep all the units in a straight line.

15 spirals

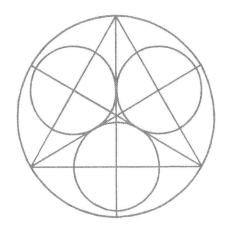

STAGE 1 Using a soft pencil, a ruler and a pair of compasses, draw a circle and add six equidistant radial lines, as shown in the diagram. Join three of the points on the circumference of the circle to create an equilateral triangle. Add three inner circles as shown in the diagram.

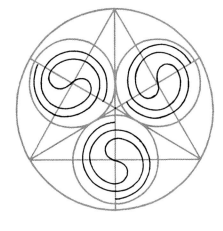

STAGE 2 Inside each small circle draw a two-coil spiral following the technique given in Stages 1-4 of Spirals 3 (page 50). Take care to end the line of each spiral exactly as shown.

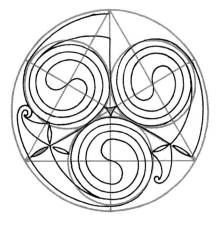

STAGE 3 Using a soft pencil, very carefully complete the spirals and add the extending curves to the ends of the two-coil spirals. Using the background lines as a guide, add the sets of small 'leaves', and the additional curves which form three very small double spirals as shown in the diagram.

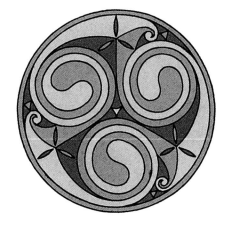

STAGE 4 Using a black felt-tip pen, go over the completed outline of the triskele design, the three sets of small ornamental 'leaves', the three small triangles, and the small triangle in the centre of the design. When the ink is dry, use a soft eraser to remove any pencil marks. Adding colour to this triskele design can be most effective. Experiment with bright contrasting colours for the separate coils of each spiral and their extensions, the sets of 'leaves' and the small ornamental triangles.

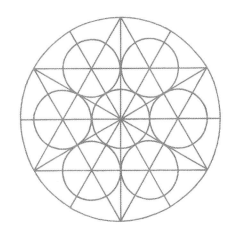

spirals

STAGE 1 Using a soft pencil, a ruler and a pair of compasses, draw a large circle with six equidistant radial lines. Mark the centre point between each radial line on the circumference of the circle, and add a further six radial lines. Join six of the points on the circumference of the circle to make two equilateral triangles. Add seven inner circles as shown in the diagram.

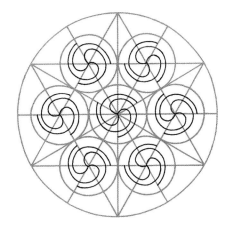

STAGE 2 Inside each small circle draw a three-coil spiral following the technique given in Stages 1-4 of Spirals 6 (page 53). Take care to end the line of each spiral exactly as shown.

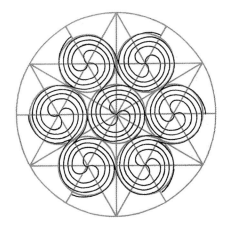

STAGE 3 Using a soft pencil, very carefully complete the spirals and add the extending curves to the ends of the seven, three-coil spirals drawn in Stage 2. Keep the pencil lines accurate, as this stage is the basis for the finished design.

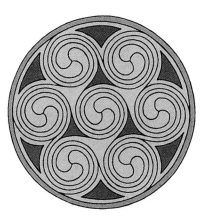

STAGE 4 Using a soft pencil carefully extend the lines of the six spirals to meet the inner large circle as shown. Add an outer circle. Using your compasses and a soft pencil, draw the six triangular shapes between the six outer small circles. The compasses will ensure that these run parallel to the inner of the two large circles. Using a black felt-tip pen, go over the completed outline of the whole design. When the ink is dry, use a soft eraser to remove any pencil marks. Add colour if wished, using felt-tip pens, crayons or paints.

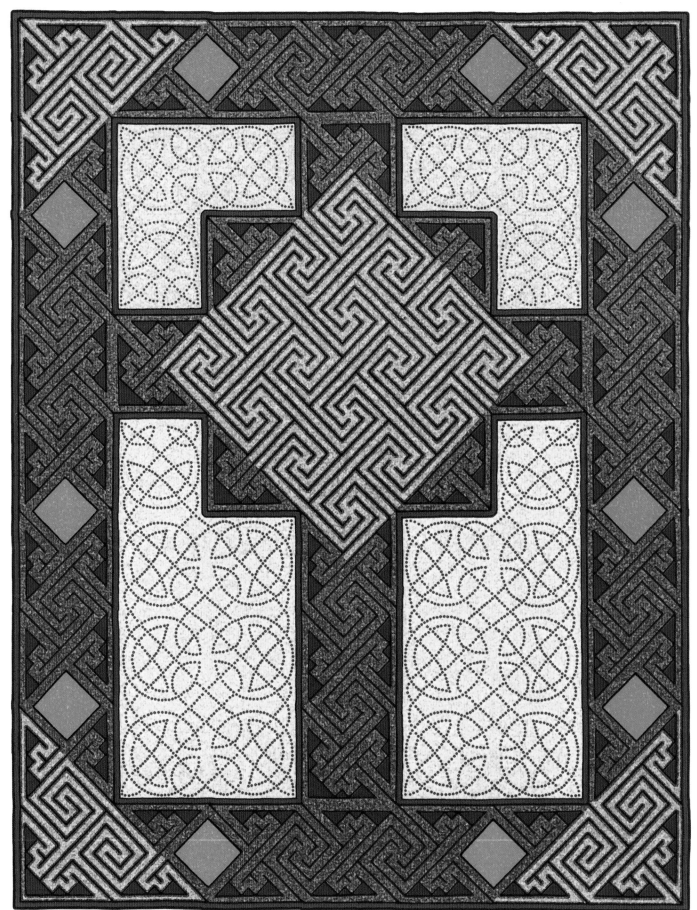

©VICTOR GONZALEZ 2002

Found in profusion in the manuscripts created by the Irish monks of the 7th and 8th centuries, key patterns can be traced back to very early times. They reached their height of complexity and beauty in the illuminated Christian gospels, but there is an example of key patterning from ancient Egypt, dating from about 3500 BC, which uses the same principles of construction. The earliest examples of key patterns using the same grid layout as the Celtic monks used can be traced back to carefully executed designs engraved on mammoth tusks found in Russia, which date from about 20,000–15,000 BC. Once you understand the careful grid preparation required to produce these designs, it becomes evident that these artists from prehistory had a sophisticated knowledge of elaborate mathematical layouts. Interesting basic grid patterning, a predecessor to the more elaborate key patterns, can be seen on one of the carved stones at Newgrange, County Meath, Ireland. It is used together with basic spiral carvings and dates from about 3200 BC.

key patterns

Design above Blue Pathways
Design left The Cross of the Labyrinth

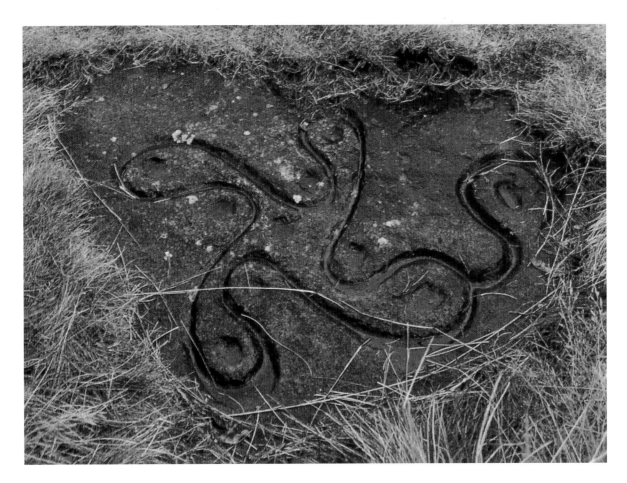

Prehistoric stylized carved swastika pattern with lobed arms, at Ilkley Moor, Yorkshire, England

As with the knotwork and spiral designs, the Irish monks working in their *Scriptoriums* developed the use of key patterns, using geometric principles to produce not only square and multi-angled patterns, but circular designs of amazing complexity. Some of the intricate circular key patterns in the Book of Kells must have taken many weeks to complete, and are not only beautiful works of art but masterpieces of mathematically accurate geometric construction. As the creativity of the art form developed, key patterns were sometimes used as full borders on pages of illuminated manuscripts, and were also incorporated to great effect on metalwork artefacts and stone carvings. Key pattern borders can be seen as the successors of the simple fret pattern borders used on the pottery and architecture of ancient Greece.

As with spiral and knotwork designs, key patterns were also used by the Irish monks and their descendants as ornamentation on the freestanding Celtic crosses and decorated slab stones. Early pillar

crosses such as the 6th century example at Glencolumbcille in County Donegal in Ireland contain bold angular outlines of a very basic form of key patterning.

A later Celtic cross can be seen at Nevern in South Wales that contains panels of both key patterns and basic knotwork, the key patterning on one panel forming an elaborate matrix of swastika designs. It should be remembered that the swastika is a very ancient and frequently used sacred design, said to incorporate the symbolism of the sun and the four seasons. A very early prehistoric carving of a stylized swastika pattern with lobed arms can be found on Ilkley Moor, Yorkshire in Britain. It is only in very recent times that the meaning of this symbol has become distorted and misrepresented.

Key patterns can also be found on some of the complex penannular Irish brooches, shaped in an almost complete ring, dating from the 7th to 9th centuries, as well as on small bronze plaques and religious sculptures such as the crucifixion plaque from Rinnagon, County Roscommon, Ireland, which dates from the late 7th century. There are further examples of basic key patterns worked in brightly coloured enamels on human figures from a slightly earlier Irish bronze bowl, looted by the Vikings and eventually excavated in Norway (see page 23).

Try your hand at some of the key pattern panels given here, starting with the simpler designs at the start of the chapter. Remember that the accurate construction of the background grid is vital for the completion of a successful design. By increasing or decreasing the size of the squares used in the grid you can make your design bigger or smaller.

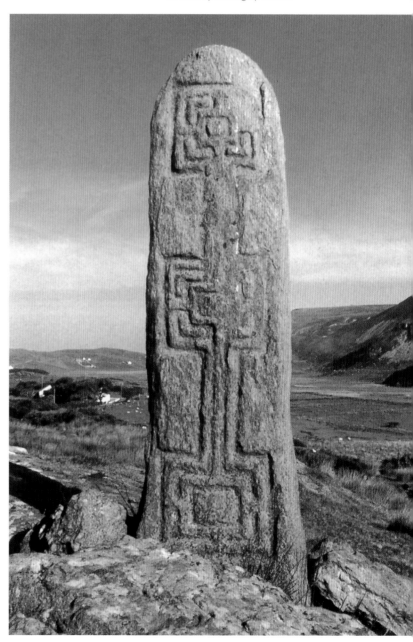

Sixth century pillar cross at Glencolumbcille in County Donegal, Ireland

key patterns

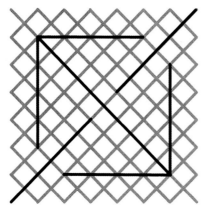

STAGE 1 Using a soft pencil and a ruler accurately draw a grid as shown in the diagram. Alternatively, trace a grid from graph paper. Remember that the accuracy of this grid will determine the accuracy of the finished design. Using a felt-tip pen and ruler add the design outline shown.

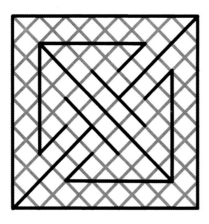

STAGE 2 Continue using the ruler and felt-tip pen and add the perimeter lines around the edge of the grid.

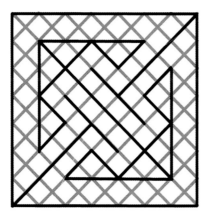

STAGE 3 Add further black lines to make the triangular shapes shown in the diagram. When the ink is dry rub out the background grid using a soft eraser.

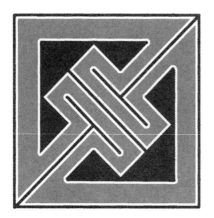

STAGE 4 Using felt-tip pens, acrylic or watercolour paints, colour in the key pattern. Use a dark colour for the triangular sections. Then choose a pale colour and fill in the surrounding areas that are shown in grey in the diagram. Carefully leave a thin white border to accentuate the main lines of the key pattern.

STAGE 1 Using a soft pencil and a ruler accurately draw a grid as shown in the diagram. Alternatively trace a gird from graph paper. Remember that the accuracy of this grid will determine the accuracy of the finished design. Using a felt-tip pen and ruler, add the diagonal lines as shown.

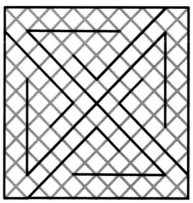

STAGE 2 Continue using the ruler and felt-tip pen and add a perimeter line around the edge of the grid. Draw the additional lines as shown.

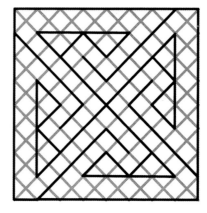

STAGE 3 Add the small triangular shapes on each side of the design, then, when the ink is dry rub out the background grid using a soft eraser.

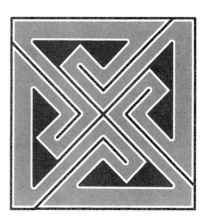

STAGE 4 Colour in the key pattern using felt-tip pens, acrylic or watercolour paints. Use a dark colour for the triangular sections and a pale colour for the surrounding areas shown in grey in the diagram. Carefully leave a very thin white line as shown – this will accentuate the main lines of the key pattern. Use a ruler and a soft pencil as a guide for this last step if wished.

69

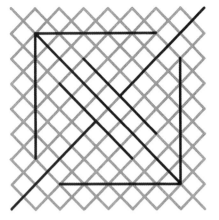

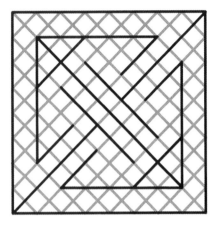

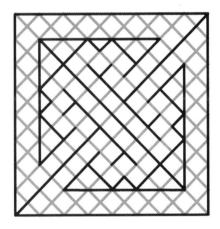

3 key patterns

STAGE 1 Using a soft pencil and a ruler accurately draw a grid as shown in the diagram. Alternatively, trace a grid from graph paper. Remember that the accuracy of this grid will determine the accuracy of the finished design. Using a felt-tip pen and ruler mark out the design shown in the diagram.

STAGE 2 Using the ruler and felt-tip pen add a perimeter line around the edge of the grid and develop the key pattern as shown.

STAGE 3 Mark in three triangles on each side of the design and add the small diagonal lines shown in the diagram to complete the outline. When the ink is dry rub out the background grid using a soft eraser.

STAGE 4 Colour in the design using felt-tip pens, acrylic or watercolour paints. Choose a dark colour for the triangular shapes and for some of the key pattern outlines, then use a paler colour to fill in the surrounding areas that are shown in grey in the diagram. Carefully leave a very thin white line as shown – this will accentuate the main lines of the key pattern. Use a ruler and a soft pencil as a guide if wished.

STAGE 1 Using a soft pencil and a ruler accurately draw a grid as shown in the diagram. Alternatively, trace a grid from graph paper. Remember that the accuracy of this grid will determine the accuracy of the finished design. Using a felt-tip pen and ruler, draw the diagonal lines of the design as shown.

STAGE 2 Continue using the ruler and felt-tip pen and add a perimeter line around the edge of the grid and develop the key pattern as shown.

STAGE 3 Mark in three triangles on each side of the design and add the small diagonal lines shown in the diagram to complete the outline. When the ink is dry rub out the grid using a soft eraser.

STAGE 4 Colour in the design using felt-tip pens, acrylic or watercolour paints. Choose a dark colour for the triangular shapes and for some of the key pattern outlines, then use a paler colour to fill in the surrounding areas that are shown in grey in the diagram. Carefully leave a very thin white line as shown – this will accentuate the main lines of the key pattern. Use a ruler and a soft pencil as a guide for this last step if wished.

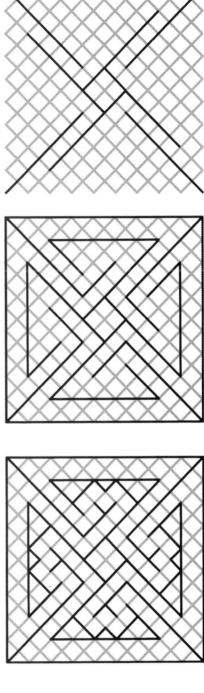

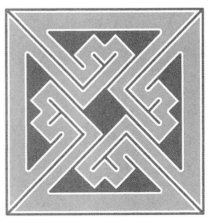

key patterns

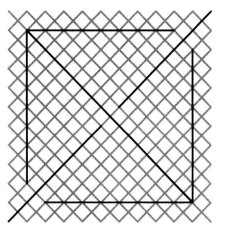

STAGE 1 Using a soft pencil and a ruler accurately draw a grid as shown in the diagram. Alternatively, trace a grid from graph paper. Remember that the accuracy of this grid will determine the accuracy of the finished design. Using a felt-tip pen and ruler mark out the design shown in the diagram.

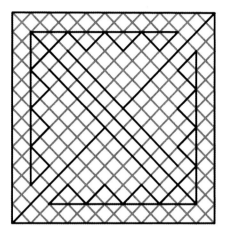

STAGE 2 Using the ruler and felt-tip pen add a perimeter line around the edge of the grid. Mark in four triangles on each side of the design and the additional diagonal lines as shown.

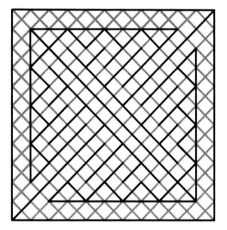

STAGE 3 Add the small diagonal lines shown in the diagram to complete the design outline. When the ink is dry, rub out the grid using a soft eraser.

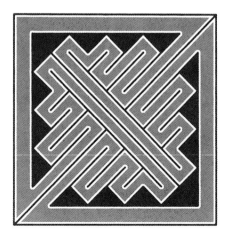

STAGE 4 Colour in the design using felt-tip pens, acrylic or watercolour paints. Choose a dark colour for the triangular shapes and for some of the key pattern outlines, then use a paler colour to fill in the surrounding areas that are shown in grey in the diagram. Carefully leave a very thin white line as shown – this will accentuate the main lines of the key pattern. Use a ruler and a soft pencil as a guide for this last step if wished.

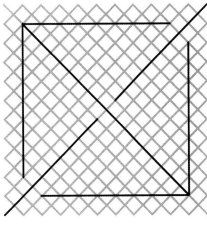

STAGE 1 Using a soft pencil and a ruler accurately draw a grid as shown in the diagram. Alternatively, trace a grid from graph paper. Remember that the accuracy of this grid will determine the accuracy of the finished design. Using a felt-tip pen and ruler mark out the design shown in the diagram.

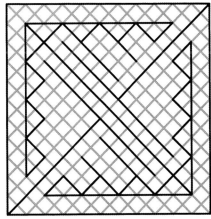

STAGE 2 Using the ruler and felt-tip pen add a perimeter line around the edge of the grid. Mark in four triangles on each side of the design and the additional diagonal lines as shown.

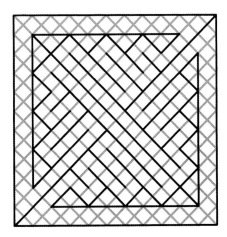

STAGE 3 Add the diagonal lines shown in the diagram to complete the design outline. When the ink is dry rub out the grid using a soft eraser.

STAGE 4 Colour in the design using felt-tip pens, acrylic or watercolour paints. Choose a dark colour for the triangular shapes and for some of the key pattern outlines, then use a paler colour to fill in the surrounding areas that are shown in grey in the diagram. Carefully leave a very thin white line as shown – this will accentuate the main lines of the key pattern. Use a ruler and a soft pencil as a guide for this last step if wished. Different colours will produce either a bold or more subtle finish to the design.

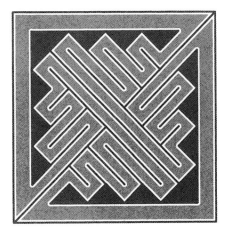

7 key patterns

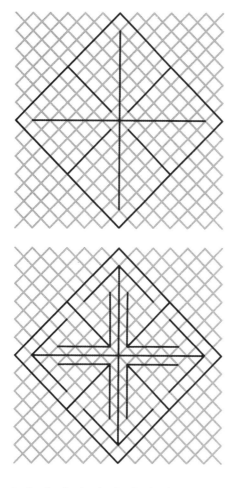

STAGE 1 Using a soft pencil and a ruler accurately draw a grid as shown in the diagram. Alternatively, trace a grid from graph paper. Remember that the accuracy of this grid will determine the accuracy of the finished design. Using a felt-tip pen and ruler mark out the design shown in the diagram.

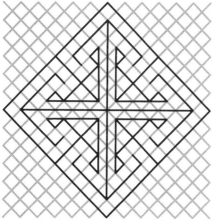

STAGE 2 Using the ruler and felt-tip pen develop the key pattern inside the diamond outline as shown in the diagram.

STAGE 3 Mark the small triangular shapes shown in the diagram and the small diagonal lines that complete the outline. When the ink is dry rub out the grid using a soft eraser.

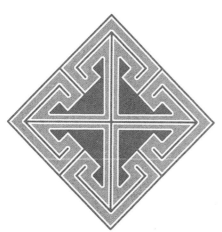

STAGE 4 Colour in the design using felt-tip pens, acrylic or watercolour paints. Choose a dark colour for the triangular shapes and for some of the key pattern outlines, then use a paler colour to fill in the surrounding areas that are shown in grey in the diagram. Carefully leave a very thin white line as shown – this will accentuate the main lines of the key pattern. Use a ruler and a soft pencil as a guide for this last step if wished. Experiment with different colours to create the finished design preferred.

STAGE 1 Using a soft pencil and a ruler accurately draw a grid as shown in the diagram. Alternatively, trace a grid from graph paper. Remember that the accuracy of this grid will determine the accuracy of the finished design, so be sure to measure and draw it very carefully, making the length exactly twice the height, and using the same number of pencil lines as shown in the diagram. Using a felt-tip pen and ruler mark out the double design shown in the diagram.

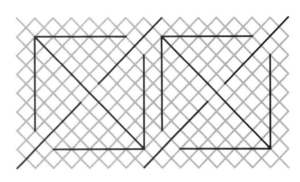

STAGE 2 Using the ruler and felt-tip pen add a perimeter line around the edge of the grid. Develop the key patterns inside the two square outlines.

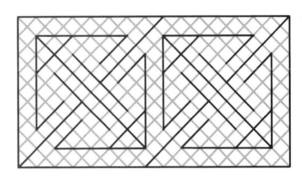

STAGE 3 Mark the small triangular shapes shown in the diagram and the small diagonal lines that complete the outline. When the ink is dry rub out the grid using a soft eraser.

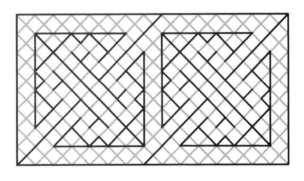

STAGE 4 Colour in the design using felt-tip pens, acrylic or watercolour paints. Choose a dark colour for the triangular shapes and for some of the key pattern outlines, then use a paler colour to fill in the surrounding areas that are shown in grey in the diagram. Carefully leave a very thin white line as shown – this will accentuate the main lines of the key pattern. Use a ruler and a soft pencil as a guide for this last step if wished.

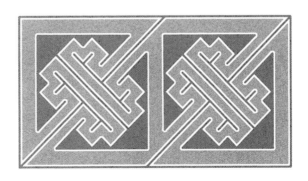

STAGE 1 Using a soft pencil and a ruler accurately draw a grid as shown in the diagram. Alternatively, trace a grid from graph paper. Remember that the accuracy of this grid will determine the accuracy of the finished design, so be sure to measure and draw it very carefully, making the length exactly twice the height, and using the same number of pencil lines as shown in the diagram. Using a felt-tip pen and ruler mark out the design shown in the diagram.

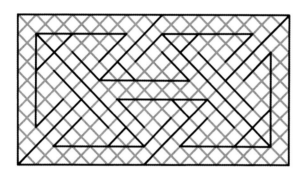

STAGE 2 Using the ruler and felt-tip pen add a perimeter line around the edge of the grid. Develop the key pattern as shown in the diagram.

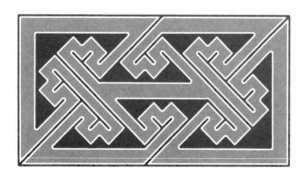

STAGE 3 Mark in the small triangular shapes as shown and the additional lines that complete the outline.

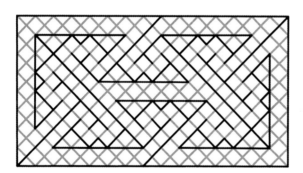

STAGE 4 Colour in the design using felt-tip pens, acrylic or watercolour paints. Choose a dark colour for the triangular shapes and for some of the key pattern outlines, then use a paler colour to fill in the surrounding areas that are shown in grey in the diagram. Carefully leave a very thin white line as shown – this will accentuate the main lines of the key pattern. Use a ruler and a soft pencil as a guide for this last step if wished.

9 key patterns

STAGE 1 Using a soft pencil and a ruler accurately draw a grid as shown in the diagram. Alternatively, trace a grid from graph paper. Remember that the accuracy of this grid will determine the accuracy of the finished design, so be sure to measure and draw it very carefully, making the length exactly twice the height, and using the same number of pencil lines as shown in the diagram. Using a felt-tip pen and ruler mark out the design shown in the diagram.

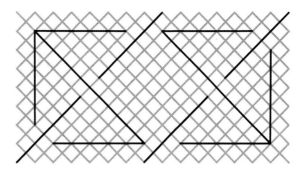

STAGE 2 Using the ruler and felt-tip pen add a perimeter line around the edge of the grid. Develop the key pattern as shown in the diagram.

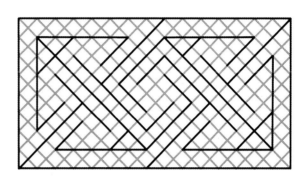

STAGE 3 Mark in the small triangular shapes as shown and the additional lines that complete the outline.

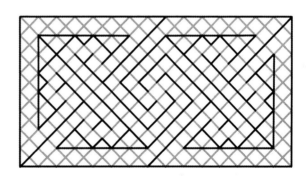

STAGE 4 Colour in the design using felt-tip pens, acrylic or watercolour paints. Choose a dark colour for the triangular shapes and for some of the key pattern outlines, then use a paler colour to fill in the surrounding areas that are shown in grey in the diagram. Carefully leave a very thin white line as shown – this will accentuate the main lines of the key pattern. Use a ruler and a soft pencil as a guide for this last step if wished. Strong colours will produce a bold design or try differ nt tones of similar colours for a softer result.

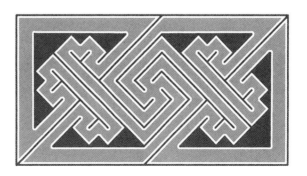

key patterns

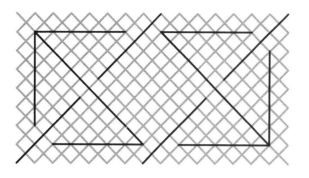

STAGE 1 Using a soft pencil and a ruler accurately draw a grid as shown in the diagram. Alternatively, trace a grid from graph paper. Remember that the accuracy of this grid will determine the accuracy of the finished design, so be sure to measure and draw it very carefully, making the length exactly twice the height, and using the same number of pencil lines as shown in the diagram. Using a felt-tip pen and ruler mark out the design shown in the diagram.

STAGE 2 Using the ruler and felt-tip pen add a perimeter line around the edge of the grid. Develop the key pattern as shown in the diagram.

STAGE 3 Mark in the small triangular shapes as shown and the additional lines that complete the outline.

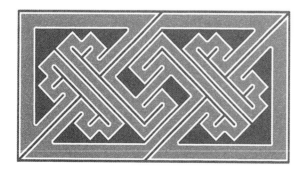

STAGE 4 Colour in the design using felt-tip pens, acrylic or watercolour paints. Choose a dark colour for the triangular and oblong shapes and for some of the key pattern outlines, then use a paler colour to fill in the surrounding areas that are shown in grey in the diagram. Carefully leave a very thin white line as shown – this will accentuate the main lines of the key pattern. Use a ruler and a soft pencil as a guide for this last step if wished.

STAGE 1 Using a soft pencil and a ruler accurately draw a grid as shown in the diagram. Alternatively, trace a grid from graph paper. Remember that the accuracy of this grid will determine the accuracy of the finished design, so be sure to measure and draw it very carefully, making the length exactly twice the height, and using the same number of pencil lines as shown in the diagram. Using a felt-tip pen and ruler mark out the design shown in the diagram.

STAGE 2 Using the ruler and felt-tip pen add a perimeter line around the edge of the grid. Develop the key pattern as shown in the diagram.

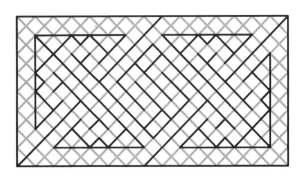

STAGE 3 Mark in the small triangular shapes as shown and the additional lines that complete the outline.

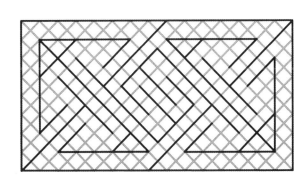

STAGE 4 Colour in the design using felt-tip pens, acrylic or watercolour paints. Choose a dark colour for the triangular and oblong shapes and for some of the key pattern outlines, then use a paler colour to fill in the surrounding areas that are shown in grey in the diagram. Carefully leave a very thin white line as shown – this will accentuate the main lines of the key pattern. Use a ruler and a soft pencil as a guide for this last step if wished.

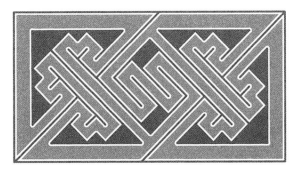

key patterns

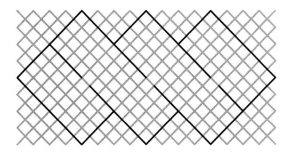

STAGE 1 Using a soft pencil and a ruler accurately draw a grid as shown in the diagram. Alternatively, trace a grid from graph paper. Remember that the accuracy of this grid will determine the accuracy of the finished design, so be sure to measure and draw it very carefully, making the length exactly twice the height, and using the same number of pencil lines as shown in the diagram. Using a felt-tip pen and ruler mark out the design shown.

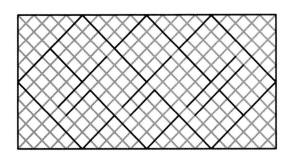

STAGE 2 Using the ruler and felt-tip pen add a perimeter line around the edge of the grid. Develop the key pattern as shown in the diagram.

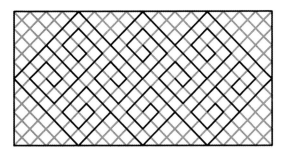

STAGE 3 Mark in the lines shown in the diagram to complete the key pattern outline. When the ink is dry, rub out the grid using a soft eraser.

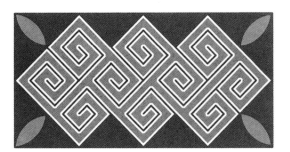

STAGE 4 Add the 'leaf' decorations in the four corners of the panel then colour in the design using felt-tip pens, acrylic or watercolour paints. Choose a dark colour for the triangular shapes around the design and for the key pattern outline, then use a paler colour to fill in the surrounding areas and 'leaf' shapes shown in grey in the diagram. Carefully leave a very thin white line as shown – this will accentuate the main lines of the key pattern. Use a ruler and a soft pencil as a guide for this last step.

STAGE 1 Using a soft pencil and a ruler accurately draw a grid as shown in the diagram. Alternatively, trace a grid from graph paper. Remember that the accuracy of this grid will determine the accuracy of the finished design, so be sure to measure and draw it very carefully, making the length exactly twice the height, and using the same number of pencil lines as shown in the diagram. Using a felt-tip pen and ruler mark out the design shown.

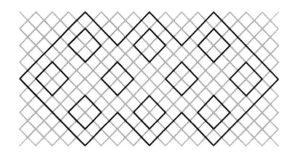

STAGE 2 Using the ruler and felt-tip pen add a perimeter line around the edge of the grid. Develop the key pattern as shown in the diagram.

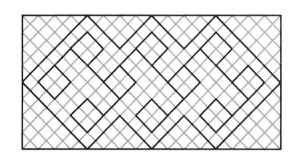

STAGE 3 Mark in the lines shown in the diagram to complete the key pattern outline. When the ink is dry, rub out the grid using a soft eraser.

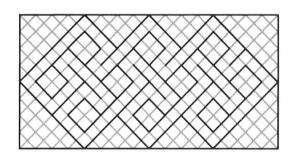

STAGE 4 Add the 'leaf' decorations around the design then colour it in using felt-tip pens, acrylic or watercolour paints. Choose a dark colour for the triangular and diamond shapes in the design and for the key pattern outline, then use a paler colour to fill in the surrounding areas and 'leaf' shapes shown in grey in the diagram. Carefully leave a very thin white line as shown – this will accentuate the main lines of the key pattern. Use a ruler and a soft pencil as a guide for this last step if wished.

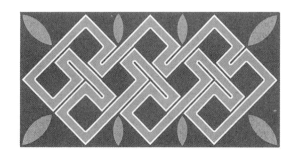

15 key patterns

STAGE 1 Using a soft pencil and a ruler accurately draw a grid as shown in the diagram. Alternatively, trace a grid from graph paper. Remember that the accuracy of this grid will determine the accuracy of the finished design. Using a felt-tip pen and ruler mark out the design shown in the diagram.

STAGE 2 Using the ruler and felt-tip pen add a perimeter line around the edge of the grid and develop the key pattern as shown.

STAGE 3 Mark in the small triangular shapes shown in the diagram. When the ink is dry, rub out the grid using a soft eraser.

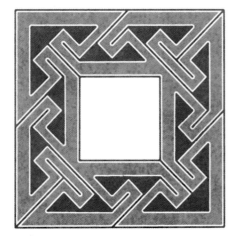

STAGE 4 Colour in the design using felt-tip pens, acrylic or watercolour paints. Choose a dark colour for the triangular shapes and for some of the key pattern outlines, then use a paler colour to fill in the surrounding areas that are shown in grey in the diagram. Carefully leave a very thin white line as shown – this will accentuate the main lines of the key pattern. Use a ruler and a soft pencil as a guide for this last step if wished. Leave the centre square white as well. Use a range of colours to create the desired effect.

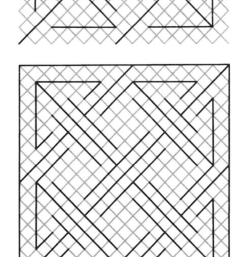

STAGE 1 Using a soft pencil and a ruler accurately draw a grid as shown in the diagram. Alternatively, trace a grid from graph paper. Remember that the accuracy of this grid will determine the accuracy of the finished design. Using a felt-tip pen and ruler mark out the design shown in the diagram.

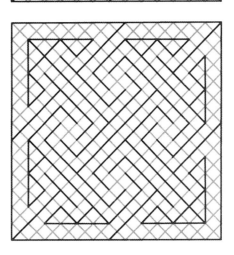

STAGE 2 Using the ruler and felt-tip pen add a perimeter line around the edge of the grid and develop the key pattern as shown.

STAGE 3 Mark in the small triangular shapes shown in the diagram and the additional lines that complete the outline. When the ink is dry, rub out the background grid using a soft eraser.

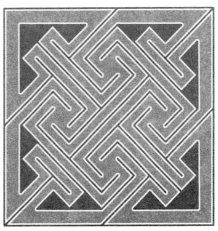

STAGE 4 Colour in the design using felt-tip pens, acrylic or watercolour paints. Choose a dark colour for the triangular shapes and for some of the key pattern outlines, then use a paler colour to fill in the surrounding areas that are shown in grey in the diagram. Carefully leave a very thin white line as shown – this will accentuate the main lines of the key pattern. Use a ruler and a soft pencil as a guide for this last step if wished. Different colour combinations will produce different effects for your final design.

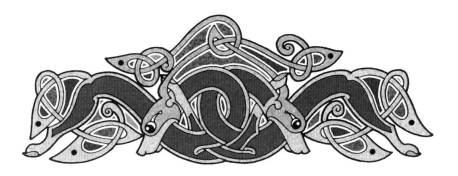

Zoomorphic designs – artwork centred on animals and beasts – occur in profusion in all the ancient illuminated Celtic gospel manuscripts. The Irish monks drew much of their inspiration from the natural world that surrounded them – but it was considered an act of blasphemy to reproduce animals and birds exactly, as that would be attempting to imitate the Creator. Instead, the monks developed their own unique and stylized animals, birds and beasts to illustrate the gospels. Most of the main pages of the Book of Kells and Lindisfarne Gospels, as well as other lesser-known manuscripts, contain wonderful and intricate examples of this type of Celtic design. Some of these are minute, and one has to marvel not only at the extraordinary artistic skills of the monks, but their ability to work on such a small scale.

The animal designs in the illuminated gospels take some of their influence from late Iron Age designs and small Celtic sculptures from the La Tène period, roughly 400–100 BC. During this time the Celts produced some beautiful bronze miniatures of their sacred animals, such as the boar, bull and horse. Later carvings of these animals, as well as the salmon and the eagle, can also be found on Pictish stones from the 7th and 8th centuries in the north-east of Scotland.

Design above Bran and Sceolaing
Design left Merlin and The Red Egg

Celtic bull sculpture by Simant Bostock based on early Pictish designs

As well as animals and beasts, the human face is portrayed in stylized form in the Irish gospel manuscripts. The faces of Jesus, St John and the Virgin Mary appear in the Book of Kells surrounded by exquisite Celtic designs and occasionally delicate scrollwork plant motifs.

Small, high relief carvings of Jesus appear on many of the Irish high crosses of the 7th century onwards, but three-dimensional carved stone heads are rare in Celtic art. However, two unique double-headed carvings can be found on the remote island of Boa, in County Fermanagh, Northern Ireland. These Celtic carvings were created several centuries earlier than the illuminated gospels, and are the only known examples of their type. Their style is said to derive from Coptic influences of the early eastern Christian church.

In this chapter we explore the way these stylized animal designs are built up. Some start with a geometric outline, but most are simply drawn freehand. Many of these animal designs use decorative devices explained in earlier chapters, particularly knotwork. It is well worth familiarizing yourself with these techniques and skills before attempting these slightly more complex Celtic artworks.

The beginner will find the designs at the start of the chapter the easiest to tackle, then the animals and people become more complex and more entwined as the chapter progresses. Start with some of the basic but beautiful examples shown in this section then with patience and perseverance you will be able to create your own unique designs.

Zoomorphic designs are very rewarding to complete. You will find many superb and elaborate examples in the illuminated pages of the Book of Kells and Lindisfarne Gospels, but do remember that the artists who created these masterpieces in the 7th century had spent years practicing and developing their skills.

One of two double-headed carvings on Boa island, County Fermanagh, Northern Ireland. Their latest possible date is 4th century CE

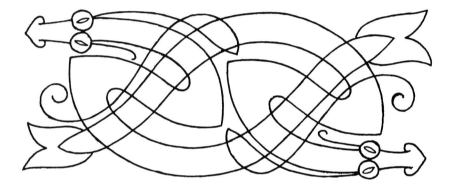

STAGE 1 Using a soft pencil draw your grid pattern accurately as shown in the diagram. Alternatively, trace a grid from graph paper. Still using pencil, add the three angular guidelines shown. Then pencil in the single line that forms the basis of the knotwork for the snakes' bodies.

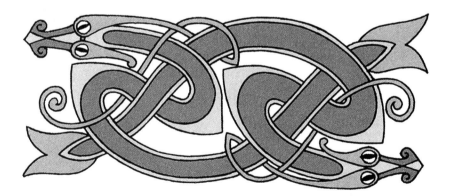

STAGE 2 Using the single line as a guide and working an equal distance on either side, create the interlaced bodies of the snakes. Add the snakes' heads, fish-tails and guidelines for the knotwork coming from the snakes' eyes. Be sure to draw these as accurately as possible, as this stage is the basis for the finished design.

STAGE 3 Go over the pencil outline with black felt-tip pen, making sure the snakes' bodies and the knotwork frills go over and under each other as shown in the diagram. When the ink is dry, rub out any remaining pencil lines with a soft eraser. With felt-tip pens or paints, colour the design in using different colours for the bodies of the snakes, their heads and fish-tails, and the additional knotwork. Bright contrasting colours are very effective.

STAGE 1 Using a soft pencil draw the outline of the bird's head, wing, tail and feet. Keep the pencil lines as accurate as possible.

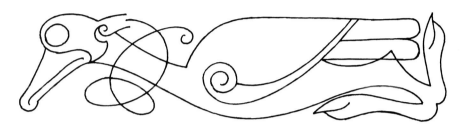

STAGE 2 Continue working in pencil and develop the outline of the bird's head, eye, wing, tail, feet, and the knotwork crest. Be sure to draw these as accurately as possible, as this stage is the basis for the finished design.

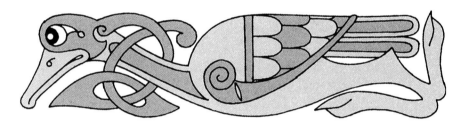

STAGE 3 Go over the pencil outline with black felt-tip pen adding the decorative detail shown in the diagram. Complete the knotwork crest using the single line as a guide and working an equal distance on either side of it to create a band that goes over and under itself as shown. When the ink is dry, rub out any remaining pencil lines with a soft eraser. Add colour to the design, using different colours for the head, eye, wing and tail feathers, and the knotwork crest. Be bold and adventurous with your colours, and experiment with different colour combinations.

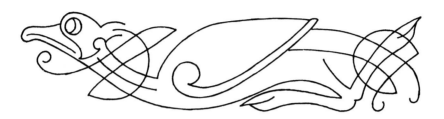

STAGE 1 Using a soft pencil draw the outline of the bird's head, wing, tail and feet. Keep the pencil lines as accurate as possible.

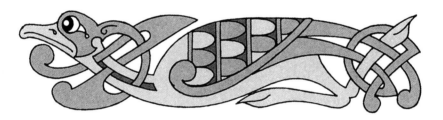

STAGE 2 Continue working in pencil and develop the outline of the bird's head, eye, wing, tail, feet and the outlines for the additional knotwork. Be sure to draw these lines as accurately as possible, as this stage is the basis for the finished design.

STAGE 3 Go over the pencil outline with black felt-tip pen adding the decorative detail shown in the diagram. Complete the knotwork using the single line as a guide and working an equal distance on either side of it to create a band that goes over and under itself as shown. When the ink is dry, rub out any remaining pencil lines with a soft eraser. Add colour to the design using different colours for the head, eye, wing and tail feathers of the bird and for the knotwork decoration. Bright contrasting colours can be very effective.

STAGE 1 Using a soft pencil draw the outline of the boar's body. Keep the pencil lines as accurate as possible.

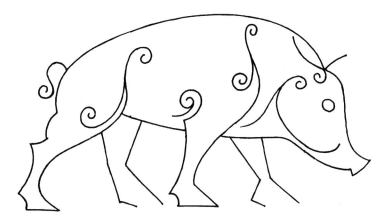

STAGE 2 Continue working in pencil and add the features of the boar's head, legs, tail and the spiral decoration on the body. Be sure to draw these lines as accurately as possible, as this stage is the basis for the finished design.

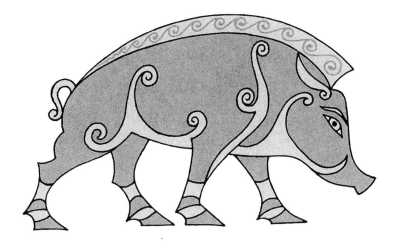

STAGE 3 Go over the pencil outline with black felt-tip pen adding the decorative detail shown in the diagram. When the ink is dry, rub out any remaining pencil lines with a soft eraser. Now, with coloured felt-tip pens or paints, use different colours for the boar's body, the spirals and the crest above his back.

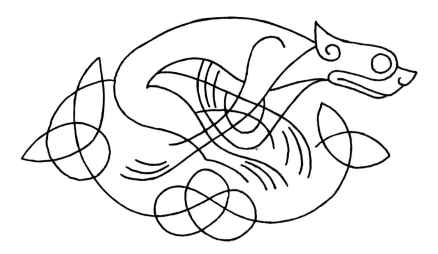

STAGE 1 Using a soft pencil draw the outline of the body of the lioness. Keep your pencil lines as accurate as possible.

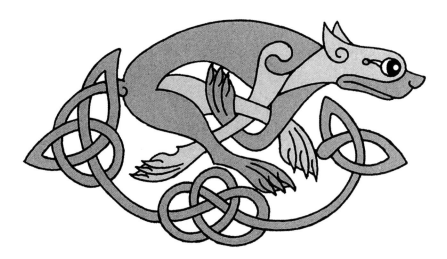

STAGE 2 Continue working in pencil and develop the outline of the head, the paws and the single weaving line that will make the surrounding knotwork. Be sure to draw these lines as accurately as possible, as this stage is the basis for the finished design.

STAGE 3 Go over the pencil outline with black felt-tip pen adding the decorative detail shown in the diagram. Complete the knotwork using the single line as a guide and working an equal distance on either side of it to create a band that goes over and under itself as shown. When the ink is dry, rub out any remaining pencil lines with a soft eraser. Use different colours for the head, eye, body and surrounding knotwork. Experiment with different colour combinations.

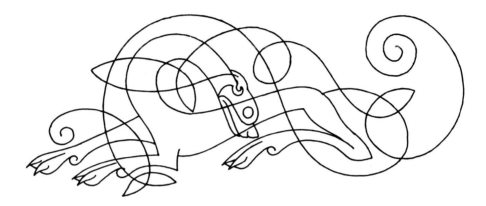

STAGE 1 Using a soft pencil draw the outline of the body of the dog. Keep the pencil lines as accurate as possible.

STAGE 2 Continue working in pencil and develop the details of the dog, and the lines that form the surrounding knotwork and the curled tail. Be sure to draw these lines as accurately as possible, as this stage is the basis for the finished design.

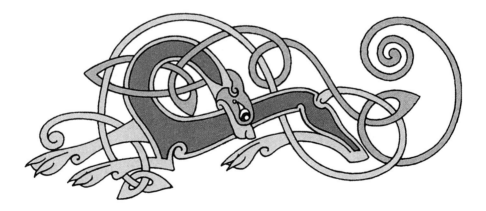

STAGE 3 Go over the pencil outline with black felt-tip pen adding the decorative detail shown in the diagram. Complete the knotwork using the single line as a guide and working an equal distance on either side of it to create a band that goes over and under itself as shown. When the ink is dry, rub out any remaining pencil lines with a soft eraser. Now, with coloured felt-tip pens or paints, use different colours for the head, eye, body, paws and surrounding knotwork tail.

animals and beasts

STAGE 1 Using a soft pencil draw the outline of the head, body and legs of the dog. Keep the pencil lines as accurate as possible.

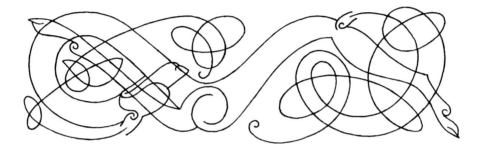

STAGE 2 Continue working in pencil and add further details of the body, the feet, the single weaving lines that will make the surrounding knotwork, and the guidelines for the spiral in the centre of the, body. Be sure to draw these lines as accurately as possible, as this stage is the basis for the finished design.

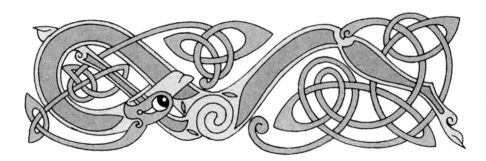

STAGE 3 Go over the pencil outline with black felt-tip pen adding the decorative detail shown in the diagram. Complete the knotwork using the single lines as a guide and working an equal distance on either side of them to create bands that go over and under each other as shown. When the ink is dry, rub out any remaining pencil lines with a soft eraser. Add colour to the design, using different colours for the head, the eye, the body with its central spiral, and the surrounding knotwork.

STAGE 1 Using a soft pencil draw the basic outline of the head, body and legs of the dog. Keep the pencil lines as accurate as possible.

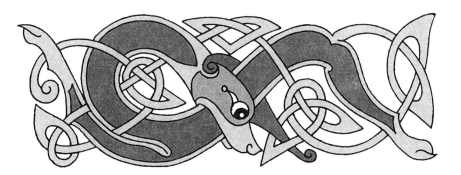

STAGE 2 Continue working in pencil and add further details of the body, the feet, and the single weaving lines that make the surrounding knotwork. Draw these lines as accurately as possible, as this stage is the basis for the finished design.

STAGE 3 Go over the pencil outline with black felt-tip pen adding the decorative detail shown in the diagram. Complete the knotwork using the single lines as a guide and working an equal distance on either side of them to create bands that go over and under each other as shown. When the ink is dry, rub out any remaining pencil lines with a soft eraser. Now, with coloured felt-tip pens or paints, use different colours for the head, eye, body and surrounding knotwork.

8 animals and beasts

STAGE 1 Using a soft pencil draw the basic outline of the heads, intertwined bodies and legs of the dogs. Keep the pencil lines as accurate as possible.

STAGE 2 Continue working in pencil and add further details of the heads and bodies, the feet and the single weaving lines that will make the surrounding decorative knotwork. Be sure to draw these lines as accurately as possible, as this stage is the basis for the finished design.

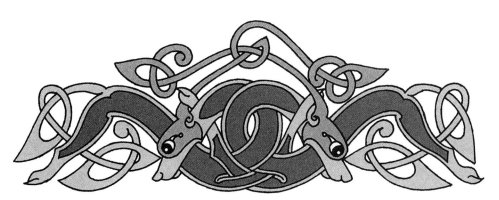

STAGE 3 Go over the pencil outline with black felt-tip pen adding the decorative detail shown in the diagram. Complete the knotwork using the single lines as a guide and working an equal distance on either side of them to create bands that go over and under each other as shown. When the ink is dry, rub out any remaining pencil lines with a soft eraser. Now, with coloured felt-tip pens or paints, use different colours for the heads, the eyes, the intertwined bodies and the surrounding knotwork with its curled ends. Bright contrasting colours bring out the details of this intricate design.

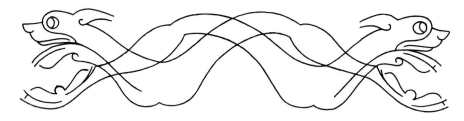

STAGE 1 Using a soft pencil draw the outline of the heads, bodies and paws of the dogs. Keep the pencil lines as accurate as possible.

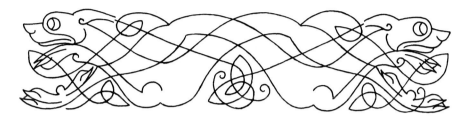

STAGE 2 Continue working in pencil and add the details of the heads and bodies, the paws, and the weaving lines that will make the surrounding decorative knotwork. Draw these lines as accurately as possible as they are the basis for the finished design.

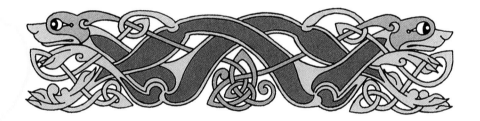

STAGE 3 Go over the pencil outline with black felt-tip pen adding the decorative detail shown in the diagram. Complete the knotwork using the single lines as a guide and working an equal distance on either side of them to create bands that go over and under each other as shown. When the ink is dry, rub out any remaining pencil lines with a soft eraser. Add colour to the design, using different colours for the heads, eyes, bodies and the surrounding knotwork, part of which forms the dogs' tails. Bright contrasting colours are very effective.

10 animals and beasts

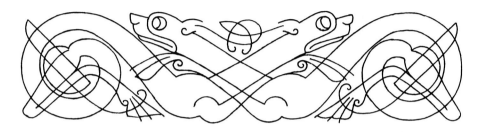

STAGE 1 Using a soft pencil draw the basic outline of the heads, curled bodies and paws of the dogs. Keep the pencil lines as accurate as possible.

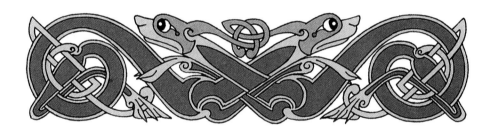

STAGE 2 Continue working in pencil and add further details of the heads and bodies, the paws and the lines that will create the additional knotwork, including their intertwined hackles. Be sure to draw these lines as accurately as possible, as this stage is the basis for the finished design.

STAGE 3 Go over the pencil outline with black felt-tip pen adding the decorative detail shown in the diagram. Complete the knotwork using the single lines as a guide and working an equal distance on either side of them to create bands that go over and under each other as shown. When the ink is dry, rub out any remaining pencil lines with a soft eraser. Now, with coloured felt-tip pens or paints, use different colours for the heads, eyes, curled bodies and surrounding knotwork.

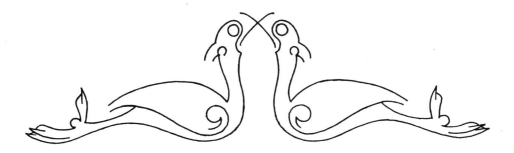

STAGE 1 Using a soft pencil draw the basic outline of the heads, bodies, feet and crossed beaks of the birds. Keep the pencil lines as accurate as possible.

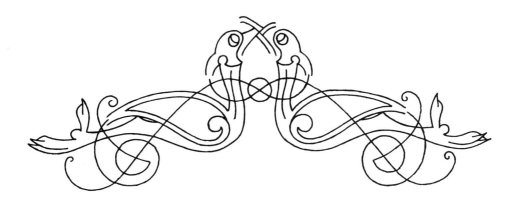

STAGE 2 Continue working in pencil and add further details of the birds, and the single weaving lines that will make the surrounding decorative knotwork with its curled ends. Work accurately as this stage is the basis for the finished design.

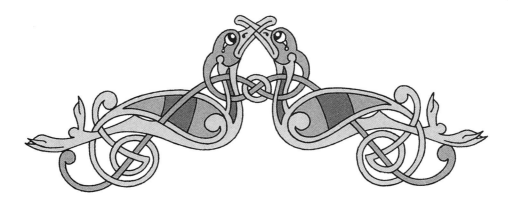

STAGE 3 Go over the pencil outline with black felt-tip pen adding the decorative detail shown in the diagram. Complete the knotwork using the single lines as a guide and working an equal distance on either side of them to create bands that go over and under each other as shown. When the ink is dry, rub out any remaining pencil lines with a soft eraser. Working with coloured felt-tip pens or paints, use different colours for the heads, kissing beaks, eyes, feathers and the surrounding knotwork with its curled finials.

13 animals and beasts

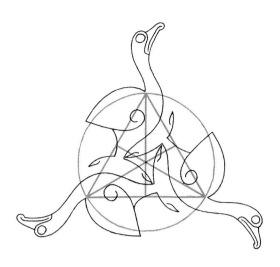

STAGE 1 Using a pair of compasses and a soft pencil, draw a circle and mark the circumference with six equidistant points. Use a ruler to join these points through the centre of the circle, then draw an equilateral triangle within the circle joining the points of three of the six lines. This framework will help to keep the design symmetrical. Draw the outline of the birds, keeping the pencil lines as accurate as possible.

STAGE 2 Continue working in pencil and add further details of the birds' heads, wings and feet.

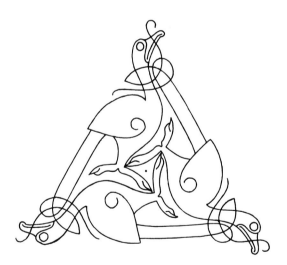

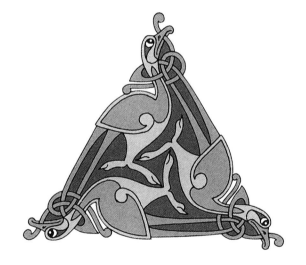

STAGE 3 Complete the outlines of the birds as shown, and add the single interweaving lines that will form the knotwork patterns extending from their tails and around their necks. Draw these lines as accurately as possible, as this stage is the basis for the finished design.

STAGE 4 Go over the pencil outline with black felt-tip pen adding the decorative detail shown in the diagram. Complete the knotwork using the single lines as a guide and working an equal distance on either side of them to create bands that go over and under each other as shown. When the ink is dry, rub out any remaining pencil lines with a soft eraser. Add colour to the different elements of the design.

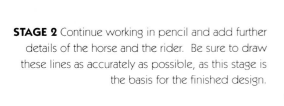

STAGE 1 Using a soft pencil draw the basic outline of the horse as shown. Keep the pencil lines as accurate as possible.

STAGE 2 Continue working in pencil and add further details of the horse and the rider. Be sure to draw these lines as accurately as possible, as this stage is the basis for the finished design.

STAGE 3 Go over the outline of the design in black felt-tip pen, copying the remaining parts from the diagram. When the ink is dry, rub out any remaining pencil lines with a soft eraser. Now, with coloured felt-tip pens or paints, use different colours for the horse's body parts and mane, and the horseman's head, hair, legs and cloak. Bright contrasting colours can be very effective.

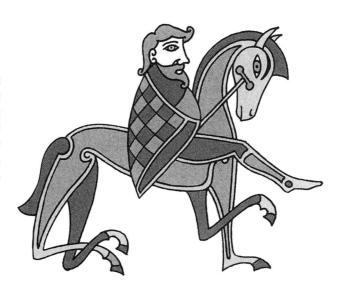

animals and beasts

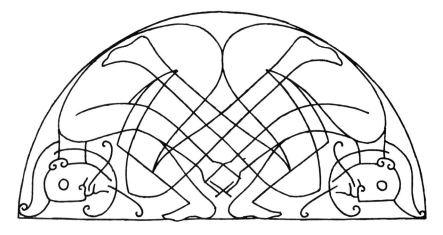

STAGE 1 Using a soft pencil and a pair of compasses, draw a semicircle then mark the radius with a dotted line. Within these guidelines draw the outline of the heads, bodies and legs of the two men. Keep the pencil lines accurate.

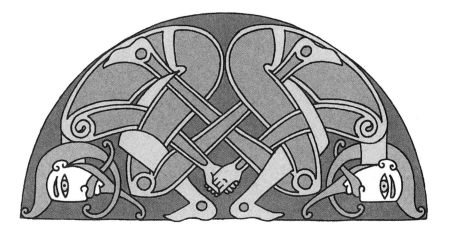

STAGE 2 Continue working in pencil and add further details of the heads, interlocking bodies, feet and hands of the men as shown. Be sure to draw these lines as accurately as possible, as this stage is the basis for the finished design.

STAGE 3 Go over the outline of the design in black felt-tip pen, copying the remaining parts from the diagram. When the ink is dry, rub out any remaining pencil lines with a soft eraser. Now, with coloured felt-tip pens or paints, use different colours for the heads, eyes, hair and beards, body sections, hands, feet, and the semicircular background. Be bold and adventurous with your colours, and experiment with different colour combinations.

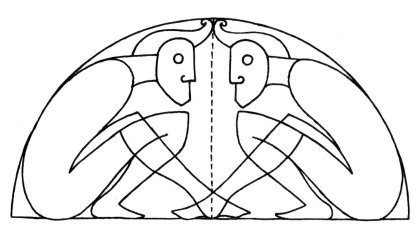

STAGE 1 Using a soft pencil and a pair of compasses, draw a semicircle then mark the radius with a dotted line. Within these guidelines draw the outline of the heads, bodies and legs of the two men. Keep the pencil lines accurate.

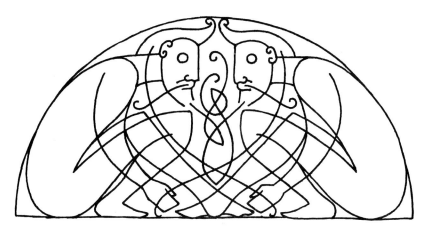

STAGE 2 Continue working in pencil and add further details of the heads, interlocking bodies, feet, and hands of the men as shown. Add the single interweaving lines that will form the knotwork design of their interlaced beards.

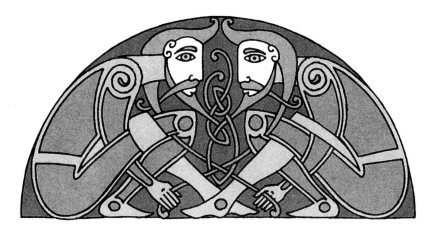

STAGE 3 Go over the outline of the design in black felt-tip pen, copying the remaining parts from the diagram. Complete the knotwork beards using the single lines as a guide and working an equal distance on either side of them to create bands that go over and under each other as shown. When the ink is dry, rub out any remaining pencil lines with a soft eraser. Add colour to the design using different colours for the heads, eyes, hair and beards, body sections, hands, feet and the semicircular background. Bright contrasting colours are very effective.

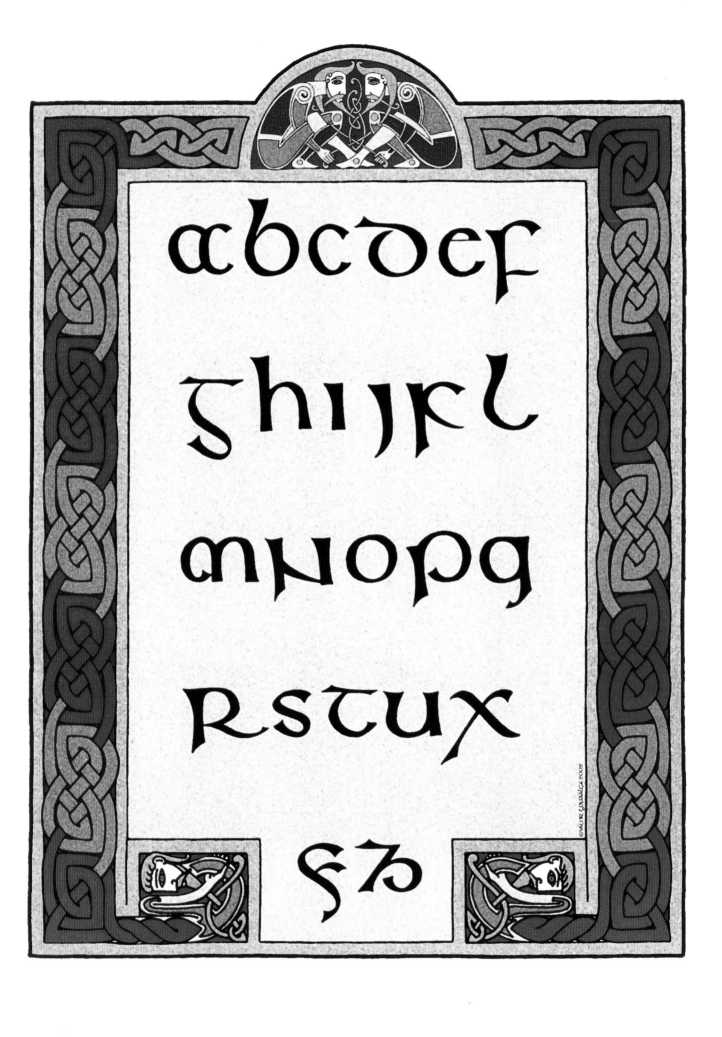

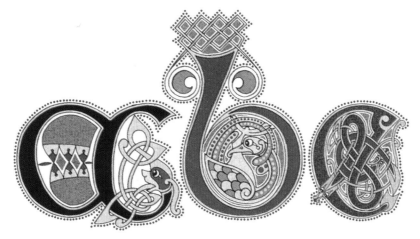

C eltic lettering can be separated into two sections – there is the plain alphabet, without decoration, which in its original form did not contain the letters 'K' and 'W', and there are the individual decorated capital letters, which are of stunning beauty, variety and complexity.

The earliest examples of full Celtic lettering are found in the manuscripts and gospels written by the Irish monks from the 5th century onwards. An analysis of this manuscript lettering is interesting, as some of the individual letters are derived from ancient Greek and Phoenician scripts. The Celtic letter 'D' is a direct derivative of the Greek letter delta. Likewise the letter 'O' sometimes appears in the illuminated gospel manuscripts as the Greek letter omega, shaped like a small 'w'. These individual letters appear in the early manuscripts alongside more conventional Roman lettering, forming a unique and stylized alphabet. The early Celtic letters 'T' and 'G' have beautiful and unique flowing shapes that are still used to characterize modern versions of the Celtic alphabet.

Ogham Script is the very earliest Celtic lettering system and it originated in Ireland before spreading to Britain. It existed alongside the Roman alphabet and was used to carve inscriptions on stone. Over three hundred of these stones survive in Ireland, many dating from the 4th and 5th centuries.

Design left A stylized modern Celtic alphabet

celtic lettering

Ogham Script consists of short, straight lines drawn at an angle to a linear axis. An upright stone in Kilmalkedar churchyard, County Kerry in Ireland has an Ogham inscription down one edge, and a hole probably used for ritual purposes carved through the top.

The decorated capital letters from the great Celtic manuscripts such as the Book of Kells are known for their exquisite beauty and intricacy. This chapter shows you how to create wonderful decorated capitals of your own. You will need all the skills and techniques learned in earlier chapters as these intricate designs incorporate the decorative devices of knotwork, spirals and complex, intertwined animals and beasts.

In this chapter there are sixteen examples of Celtic capital letters. Each one is an original design, and clear stages are shown so that they can be recreated from simple beginnings. Once you have learnt the freehand principles of the construction of lettering, you will eventually be able to create your own variations and additions.

You may also wish to incorporate lower-case Celtic letters into your designs and you could use the alphabet shown on page 104, which is based on '*Insular Majuscule*' lettering, the script used in the Book of Kells. Again, once you have worked with these smaller letters and feel comfortable drawing them, you may decide to create your own stylized versions, and perhaps include some modern additions.

This rich and rewarding art form can be used to create personalized writing paper, greetings and business cards, or individual design projects. Single, large decorated letters can be created which are works of art in their own right. These can be coloured in using felt-tip pens or paints, and then displayed as individual pictures.

Be creative – once you have mastered the basic principles shown in this chapter, you can then carefully use these methods to produce your own unique and beautiful lettering. Have fun!

Holed Ogham stone in the churchyard at Kilmalkedar, County Kerry, Ireland

STAGE 1 Draw the basic outline of the letter as shown in the diagram. Draw this freehand in pencil and accustom yourself to the curves in the letter's shape.

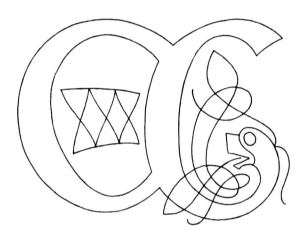

STAGE 2 Add the guidelines for the lion's head and paws. Draw these accurately in pencil, as they are the templates for the finished letter. The single weaving line on the right side of the letter is a guideline for the decorative knotwork, which must be completed using the standard method explained in the knotwork chapter (pages 24-43).

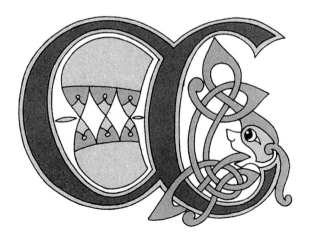

STAGE 3 Go over the pencil design in black felt-tip pen, copying the remaining elements from the diagram and completing the knotwork carefully. When the ink is dry, rub out any remaining pencil lines with a soft eraser. Use different colours for the body of the letter and for the different elements of the lion and the knotwork decoration.

STAGE 1 Draw the basic outline of the letter as shown in the diagram. Draw this freehand in pencil and accustom yourself to the curves in the letter's shape.

STAGE 2 Add the guidelines for the knotwork (pages 28-43), the spiral ends and the curled-up bird. Use pencil and try to keep these guidelines as accurate as possible.

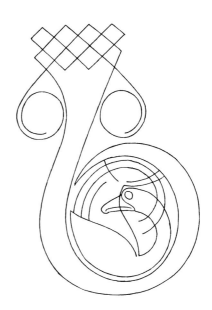

STAGE 3 Go over the outline of the design in black felt-tip pen, copying the remaining parts from the diagram and completing the knotwork and spirals carefully. When the ink is dry, rub out any remaining pencil lines with a soft eraser. Use coloured felt-tip pens or paints for the body of the letter, the knotwork and two spirals at the top of the letter, and the different parts of the bird's body. Be bold and adventurous with your colours, and experiment with different colour combinations.

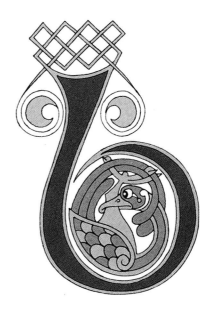

3 lettering

STAGE 1 Draw the basic outline of the letter as shown in the diagram. Draw this freehand in pencil and accustom yourself to the curves in the letter's shape.

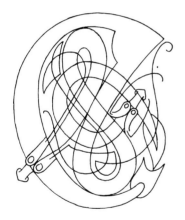

STAGES 2 Draw the outline of the two fish-tailed snakes shown in the diagram.

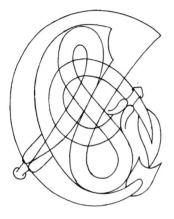

STAGES 3 Add further details to the snakes, and the single lines that will be the guide for the interweaving knotwork design in the finished letter.

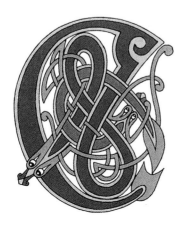

STAGE 4 Go over the outline of the design in black felt-tip pen, copying the remaining parts from the diagram and completing the knotwork carefully (page 28-43). When the ink is dry, rub out any remaining pencil lines with a soft eraser. Use coloured felt-tip pens or paints to add different colours to the body of the letter, the knotwork, the snakes' heads, tails and eyes.

4 lettering

STAGE 1 Draw the basic outline of the letter as shown in the diagram. Draw this freehand in pencil and accustom yourself to the curves in the letter's shape.

STAGE 2 Add the outline of the stylized dog and the single lines that will be the guide for the interweaving knotwork. Use pencil and try to keep these guidelines as accurate as possible.

STAGE 3 Go over the outline of the design in black felt-tip pen, copying the remaining parts from the diagram and completing the knotwork carefully (pages 28-43). When the ink is dry, rub out any remaining pencil lines with a soft eraser. Now, with coloured felt-tip pens or paints, use different colours for the body of the letter and the different sections of the stylized Celtic dog.

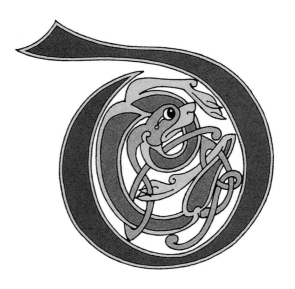

5 lettering

STAGE 1 Draw the basic outline of the letter as shown in the diagram. Draw this freehand in pencil and accustom yourself to the curves in the letter's shape.

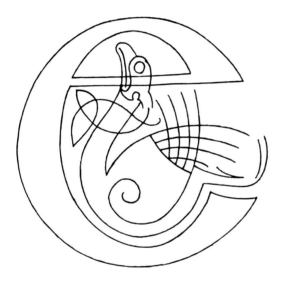

STAGE 2 Add the guidelines for the bird's head and body, and surrounding knotwork. Draw these accurately in pencil, as they are the basis of the finished letter.

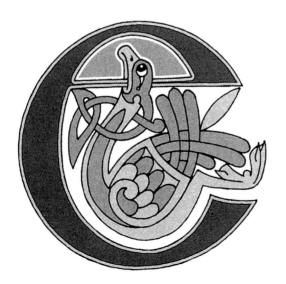

STAGE 3 Go over the outline of the design in black felt-tip pen, copying the remaining parts from the diagram and completing the knotwork carefully (page 28-43). When the ink is dry, rub out any remaining pencil lines with a soft eraser. Use different coloured felt-tip pens or paints for the body of the letter, the bird's head, body and surrounding knotwork.

STAGE 1 Draw the basic outline of the letter as shown in the diagram. Draw this freehand in pencil and accustom yourself to the curves in the letter's shape.

STAGE 2 Add the guidelines for the spirals. Draw these accurately in pencil, as they are the basis of the finished letter.

STAGE 3 Go over the outline of the design in black felt-tip pen, carefully completing the spirals (pages 48-63) and adding the decorative elements shown in the diagram. When the ink is dry, rub out any remaining pencil lines with a soft eraser. Now, with coloured felt-tip pens or paints, use different colours for the body of the letter and the different sections of the spirals. Bright contrasting colours are very effective.

7 lettering

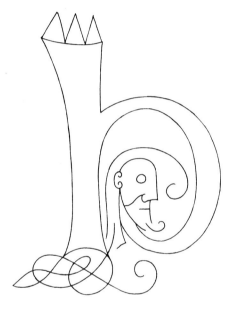

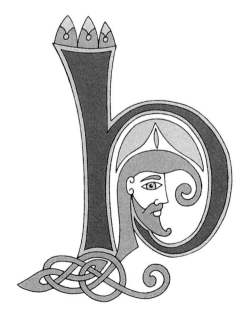

STAGE 1 Draw the basic outline of the letter as shown in the diagram. Draw this freehand in pencil and accustom yourself to the curves in the letter's shape.

STAGE 2 Add the guidelines for the head, the knotwork hair, and the paws. Draw these accurately in pencil, as they are the basis of the finished letter.

STAGE 3 Go over the outline of the design in black felt-tip pen, copying the remaining parts from the diagram and completing the knotwork carefully (pages 28-43). When the ink is dry, rub out any remaining pencil lines with a soft eraser. Use different coloured felt-tip pens or paints to colour in the body of the letter, the head, the interlaced hair and the main letter embellishments. Bright contrasting colours are very effective.

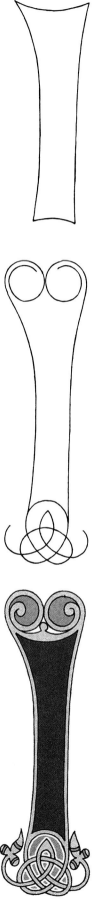

STAGE 1 Draw the basic outline of the letter as shown in the diagram. Draw this freehand in pencil and accustom yourself to the curves in the letter's shape.

STAGE 2 Add the guidelines for the spirals at the top of the letter, and the knotwork with trefoil endings at the bottom. Draw these accurately in pencil, as they are the basis of the finished letter.

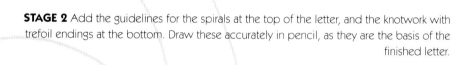

STAGE 3 Go over the outline of the design in black felt-tip pen, copying the remaining parts from the diagram and completing the spirals (pages 48-63) and knotwork (pages 28-43) carefully. When the ink is dry, rub out any remaining pencil lines with a soft eraser. Now, with coloured felt-tip pens or paints, use different colours for the body of the letter, the knotwork with its trefoils, and the spirals. Use bright contrasting colours and experiment with different colour combinations.

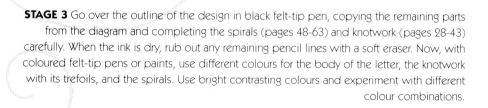

STAGE 1 Draw the basic outline of the letter as shown in the diagram. Draw this freehand in pencil and accustom yourself to the curves in the letter's shape.

STAGE 2 Add the guidelines for the bird's head and knotwork crest on the left, and the triquetra (three-pointed knot) on the right. Draw these accurately in pencil, as they are the basis of the finished letter.

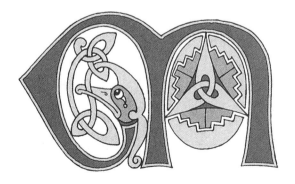

STAGE 3 Go over the outline of the design in black felt-tip pen, copying the remaining parts from the diagram and completing the knotwork designs carefully (pages 28-43). When the ink is dry, rub out any remaining pencil lines with a soft eraser. Now, with coloured felt-tip pens or paints, use different colours for the body of the letter, the bird's head, the triquetra and surrounding ornamentation. Use bright contrasting colours or try similar colours and shades for a more subtle finish.

STAGE 1 Draw the basic outline of the letter as shown in the diagram. Draw this freehand in pencil and accustom yourself to the curves in the letter's shape.

STAGE 2 Add the guidelines for the two intertwining birds inside the letter. Draw these accurately in pencil, as they are the basis of the finished design.

STAGE 3 Go over the outline of the design in black felt-tip pen, copying the remaining parts from the diagram. When the ink is dry, rub out any remaining pencil lines with a soft eraser. Use coloured felt-tip pens or paints and colour in the the letter, the heads, eyes and feathers of the two birds. Leave the inside of the letter without colour so the decorative detail of the design stands out clearly.

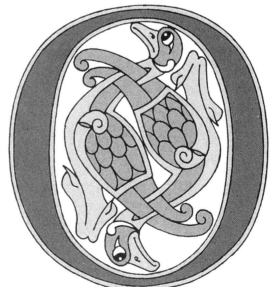

STAGE 1 Draw the basic outline of the letter as shown in the diagram. Draw this freehand in pencil and accustom yourself to the curves in the letter's shape.

STAGE 2 Add the guidelines for the triquetra (a three-pointed knot) inside the head of the 'P', and the additional knotwork. Draw these accurately in pencil, as they are the basis of the finished letter.

STAGE 3 Go over the outline of the design in black felt-tip pen, completing the knotwork carefully (pages 28-43) and adding the decorative 'grapes' and 'leaves' as shown in the diagram. When the ink is dry, rub out any remaining pencil lines with a soft eraser. Now, with coloured felt-tip pens or paints, use different colours for the body of the letter, knotwork, triquetra and grapes.

12 lettering

STAGE 1 Draw the basic outline of the letter as shown in the diagram. Draw this freehand in pencil and accustom yourself to the curves in the letter's shape.

STAGE 2 Add the guidelines for the bird and the knotwork crest and the trefoil endings. Draw these accurately in pencil, as they are the basis of the finished letter.

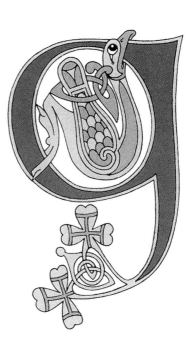

STAGE 3 Go over the outline of the design in black felt-tip pen, completing the knotwork carefully and adding the trefoil endings (pages 28-43). When the ink is dry, rub out any remaining pencil lines with a soft eraser. Use coloured felt-tip pens or paints to colour in the body of the letter, the different parts of the bird, the knotwork and the trefoils. Bright contrasting colours are very effective.

lettering

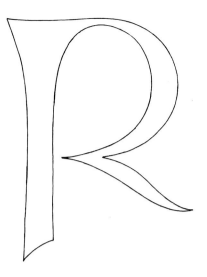

STAGE 1 Draw the basic outline of the letter as shown in the diagram. Draw this freehand in pencil and accustom yourself to the curves in the letter's shape.

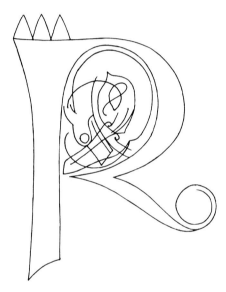

STAGE 2 Add the guidelines for the stylized Celtic dog, the paws and the spiral letter ending. Draw these accurately in pencil, as they are the basis of the finished letter.

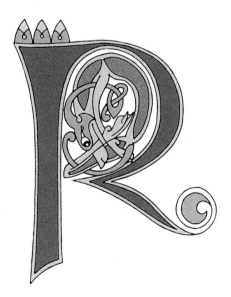

STAGE 3 Go over the outline of the design in black felt-tip pen, copying the remaining parts from the diagram and completing the knotwork carefully (pages 28-43). When the ink is dry, rub out any remaining pencil lines with a soft eraser. Now, with coloured felt-tip pens or paints, use different colours for the body of the letter, the stylized dog the paws and the spiral.

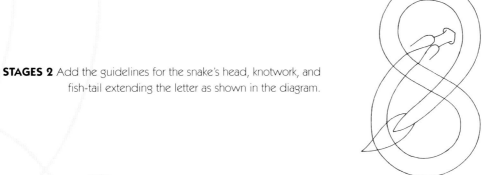

STAGE 1 Draw the basic outline of the letter as shown in the diagram. Draw this freehand in pencil and accustom yourself to the curves in the letter's shape.

STAGES 2 Add the guidelines for the snake's head, knotwork, and fish-tail extending the letter as shown in the diagram.

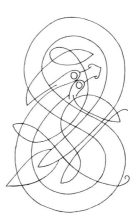

STAGES 3 Carefully pencil in the single lines that are the guides for the interweaving knotwork in the finished letter. Follow the diagram exactly.

STAGE 4 Go over the outline of the design in black felt-tip pen, copying the remaining parts from the diagram and completing the complex knotwork carefully (pages 28-43). When the ink is dry, rub out any remaining pencil lines with a soft eraser. Now, with coloured felt-tip pens or paints, use different colours for the body of the letter, the snake's head and eyes, the knotwork and fish-tail.

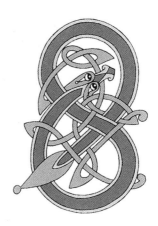

STAGE 1 Draw the basic outline of the letter as shown in the diagram. Draw this freehand in pencil and accustom yourself to the curves in the letter's shape.

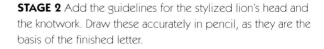

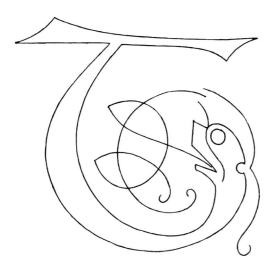

STAGE 2 Add the guidelines for the stylized lion's head and the knotwork. Draw these accurately in pencil, as they are the basis of the finished letter.

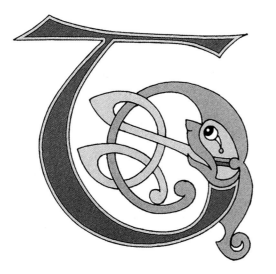

STAGE 3 Go over the outline of the design in black felt-tip pen, copying the remaining parts from the diagram and completing the knotwork carefully (pages 28-43). When the ink is dry, rub out any remaining pencil lines with a soft eraser. Use coloured felt-tip pens or paints, and colour in the letter, the features of the lion's head and the knotwork. Experiment with different colour combinations.

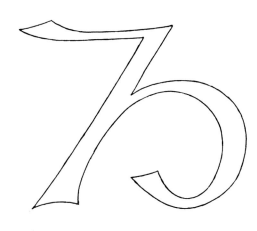

STAGE 1 Draw the basic outline of the letter as shown in the diagram. Draw this freehand in pencil and accustom yourself to the curves in the letter's shape.

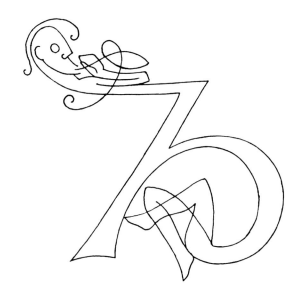

STAGE 2 Add the guidelines for the parts of the human figure and attached knotwork. Draw these accurately in pencil, as they are the basis of the finished letter.

STAGE 3 Go over the outline of the design in black felt-tip pen, copying the remaining parts from the diagram and completing the knotwork beard carefully (pages 28-43). When the ink is dry, rub out any remaining pencil lines with a soft eraser. Now, with coloured felt-tip pens or paints, use different colours for the body of the letter, the different parts of the human figure, and the surrounding knotwork. Bright contrasting colours will work well with this design, and you can experiment with different colour combinations.

BIBLIOGRAPHY

CELTIC ART

Celtic Art – from its beginnings to The Book of Kells, Ruth and Vincent Megaw; Thames and Hudson 2002

Early Celtic Designs, Ian Stead and Karen Hughes; British Museum Press 1997

Celtic Art – the methods of construction, George Bain; Constable 1991

The Celtic Art Source Book, Courtney Davis; Blandford Press 1988

Celtic Art in Pagan and Christian Times, J Romilly Allen; Bracken Books 1993 (reprint of 1904)

Early Celtic Art in Britain and Ireland, Ruth and Vincent Megaw; Shire Archaeology 1994

Later Celtic Art in Britain and Ireland, Lloyd Laing; Shire Archaeology 1987

The Book of Kells, described by Sir Edward Sullivan; Studio Editions 1992 (reprint of 1920)

The Lindisfarne Gospels, Janet Backhouse; Phaidon Press 1981

CELTIC CRAFTS

The Work of Angels – Masterpieces of Celtic Metalwork 6th–9th centuries, Susan Youngs, ed; British Museum Press 1990

Celtic Crafts – The Living Tradition, David James; Blandford Press 1998

Celtic Designs – An Arts and Crafts Source Book, David James; Cassell, 2002

HISTORY

The Ancient Celts, Barry Cunliffe; Oxford University Press 1997

The Celtic Empire – 1000 BC–51AD, Peter Beresford Ellis; Constable 1992

Towns, Villages and Countryside of Celtic Europe, F Audoze and O Buchsenschutz; Batsford 1991

Celtic Britain – Britain Before The Conquest, Lloyd Laing; Routledge & Kegan Paul 1979

Celtic Scotland, Ian Armit; Batsford Ltd/Historic Scotland 1997

Picts, Gaels and Scots, Sally M Foster; Batsford Ltd/Historic Scotland 1996

The Road Wet, the Wind Close – Celtic Ireland, James Charles Roy; Gill and MacMillan 1986

The Celtic Cross – An Illustrated History and Celebration, Nigel Pennick; Blandford Press 1997

Stone Crosses in Cornwall, Andrew Langdon; Federation of Old Cornwall Societies 1997 (series of four illustrated p/bs)

Celtic Warriors, W F and J N G Ritchie; Shire Archaeology 1997

Wales – Land of Mystery and Magic, Donald Gregory; Carreg Gwalch 1999

Wales – The First Place, Jan Morris & Paul Wakefield; Aurum Press 1982

The Manx Crosses Illuminated, Maureen Costain Richards; Crosshag Publications 1988

Music and the Celtic Otherworld, Karen Ralls-MacLeod; Edinburgh University Press 2000

CELTIC SPIRITUALITY

Iona, Fiona Macleod; Floris Classics 1991 (1910 reprint)

The Celtic Year, Shirley Toulson; Element Press 1993

The Celtic Way, Ian Bradley; Darton, Longman and Todd 1993

Wisdom of the Celtic Saints, Edward C Sellner; Ave Maria Press, Indiana, 1993

The Age of Saints in the Early Celtic Church, Nora Chadwick; Llanerch Press 1997 (1960 reprint)

The Celtic Resource Book, Ven. Martin Wallace; Church House Publishing 1998

The Sacred Isle – Beliefs and Religion in Pre-Christian Ireland, Daithi O'Hogain; Collins Press 1999

The Monumental History of the Early British Church, J Romilly Allen; Llanerch Press 1996 (1889 reprint)

Celtic Sacrifice – Pre-Christian Ritual and Religion, Marion K Pearce; Capall Bann Publishing 1988

FOLKLORE AND MYTHOLOGY

The Fairy Faith in Celtic Countries, W Y Evans-Wentz; Colin Smythe, 1977 (1911 reprint)

Landscapes of Legend, John Matthews and Michael Stead; Blandford Press, 1997

The Illustrated Guide to Celtic Mythology, T W Rolleston; Studio Editions, London, 1993

Celtic Women – In Legend, Myth and History; Lyn Webster-Wilde; Blandford Press 1998

Celtic Myths – The Legendary Past; Miranda Green; British Museum Press 1993

Sacred Celtic Animals, Marion Davies; Capall Bann Publishing 1998

Celtic Myth and Legend – an A–Z of People and Places; Mike Dixon-Kennedy; Blandford Press 1997

Celtic Myths – Celtic Legends, R J Stewart; Blandford Press 1994

Tales of the Celtic Otherworld, John Matthews; Blandford Press 1998

Classic Celtic Fairy Tales, John Matthews; Blandford Press 1997

Hero Myths and Legends of Britain and Ireland, M I Ebbutt; Blandford Press 1995

Mythical Journeys – Legendary Quests, Moyra Caldecott; Blandford Press 1996

The Creatures of Celtic Myth, Bob Curran; Cassell 2000

ANCIENT AND MEGALITHIC SITES

The Standing Stones of Europe, A Service and J Bradbury; J M Dent Ltd 1993

Megalithic Brittany, Aubrey Burl; Thames and Hudson 1985

(by the same author: Stone Circles of the British Isles; Prehistoric Avebury; Rites of the Gods)

Prehistoric Sites of The Gower and West Glamorgan, Wendy Hughes; Logaston Press 1999

Stonehenge Complete, Christopher Chippendale; Thames and Hudson 1989

GENERAL READING

Celtic Connections – The Ancient Celts, Their Traditions and Living Legacy, David James and Simant Bostock; Blandford Press 1996

Holy Places of Celtic Britain, Mick Sharp; Blandford Press 1997

The Sacred Yew, Anand Cheton and Diana Brueton; Arkana Press 1994

Coinage in the Celtic World, Daphne Nash; Seaby 1987

8000 Years of Ornament – a Handbook of Motifs, Eva Wilson; British Museum Press 1994

Sutton Hoo – Burial Ground of Kings? Martin Carver; British Museum Press 1998

The Atlas of Archaeology, Mick Aston and Tim Taylor (Channel 4 'Time Team'); Dorling Kindersley 1998

Celtic Dreams – An Anthology of Irish Poetry, Chris Down; Blandford Press 1998

INDEX

Pages numbers in *italics* refer to captions

Picture credits

page 6 The Board of Trinity College, Dublin
page 12 The Board of Trinity College, Dublin; photograph ©: The Bridgeman Art Library
page 21 Trustees of the British Museum